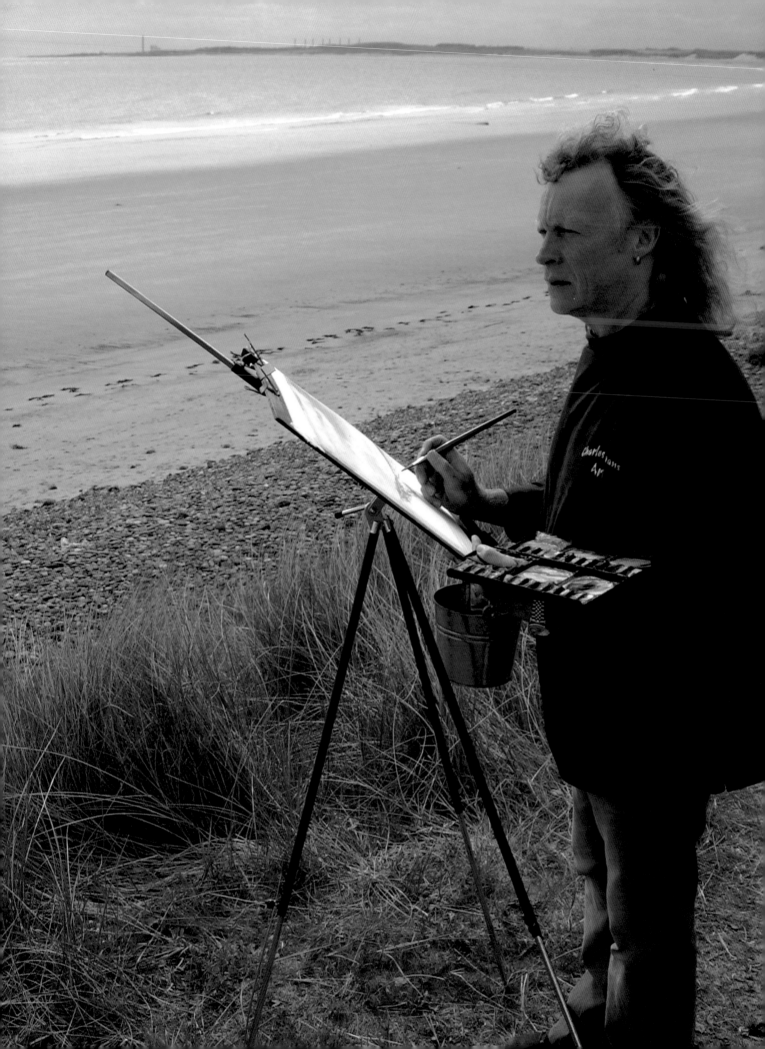

Quick & Clever
WATERCOLOUR LANDSCAPES

Charles Evans

David and Charles

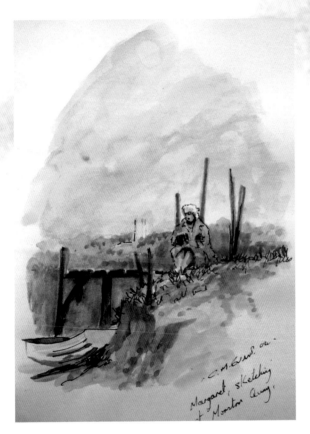

This book is dedicated to the memory of Margaret Abbey, who is seen here sketching at Morston Quay. This was the last time I saw her at her happiest, on a painting holiday; it was a pleasure to have known her, and the world is a sadder place without her.

A DAVID & CHARLES BOOK
Copyright © David & Charles Limited 2005, 2006

David & Charles is an F + W Publications Inc. company
4700 East Galbraith Road
Cincinnati, OH 45236

First published in the UK in 2005
First US paperback edition 2005
First UK paperback edition 2006
Reprinted 2006, 2007, 2008
Text and illustrations Copyright © Charles Evans 2005, 2006

A catalogue record for this book is available from the British Library.

ISBN-13: 978-0-7153-1931-4 hardback
ISBN-10: 0-7153-1931-0 hardback

ISBN-13: 978-0-7153-1932-1 paperback
ISBN-10: 0-7153-1932-9 paperback

Printed in China by SNP Leefung
for David & Charles
Brunel House Newton Abbot Devon

Commissioning Editor Mic Cady
Desk Editor Lewis Birchon
Project Editor Ian Kearey
Art Editor Ali Myer
Production Controller Kelly Smith

Photography by Karl Adamson

Visit our website at www.davidandcharles.co.uk

David & Charles books are available from all good bookshops; alternatively you can contact our Orderline on 0870 9908222 or write to us at FREEPOST EX2 110, D&C Direct, Newton Abbot, TQ12 4ZZ (no stamp required UK only); US customers call 800-289-0963 and Canadian customers call 800-840-5220.

Contents

Introduction

My kind of painting is not about fiddling or messing about with lots of complex processes and tiny brushes – it's about slapping on paint using big brushes, getting dirty and having fun. The point is that this is all supposed to be about fun and enjoyment; that's why we start painting.

The one thing I can promise in this book is that you won't be bogged down by technical jargon or confusing terms; instead, there will be words and phrases such as slap it on, a daub, squiggly bits and splat. This is about as technical as I usually get, although I have included a few more technical phrases so you can recognize them when you need to.

For what seems like over a hundred years, I have always had tremendous passion and enjoyment for my painting. People tell me, 'You always make it look so easy', but if you are using big brushes and having fun and slapping on the paint, then results certainly do come quickly and you have definitely enjoyed yourself; and that, remember, is what it's all about.

A quick look at the contents of this book will show that it's not the type where you have to start at the easy beginning and work your way through to the complex end, missing out sections at your peril. The name of the game is to get you painting the watercolour landscapes that you want to paint, so you can dip in and out as suits you best. (But that's not to say you can't work from beginning to end if you want, of course.)

The exercises are designed to be very quick and easy, and should help you build up the confidence to tackle the parts and details that people often find difficult – skies, boats, trees, people and animals, and buildings. The projects incorporate all the exercise themes, and also introduce new ideas and solutions that you can work with and use in your own paintings.

If you glean anything from this book, it will hopefully not be, as we are told so many times, that watercolours are the most difficult painting medium; it will be that they are the most enjoyable one, with the most instant effects. In addition, the usual trauma of making a mistake can be eased by the fact that this is not the ruination or the ending of the painting; if you blunder, simply wash it out and do it again. So sit back, relax – and enjoy.

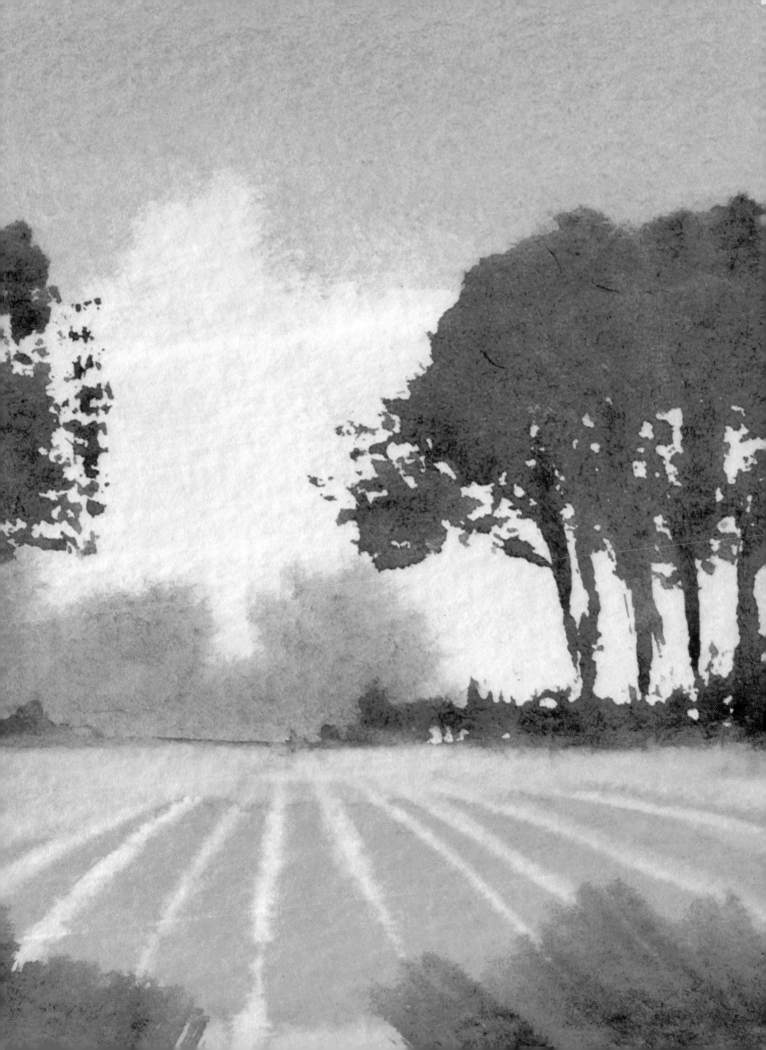

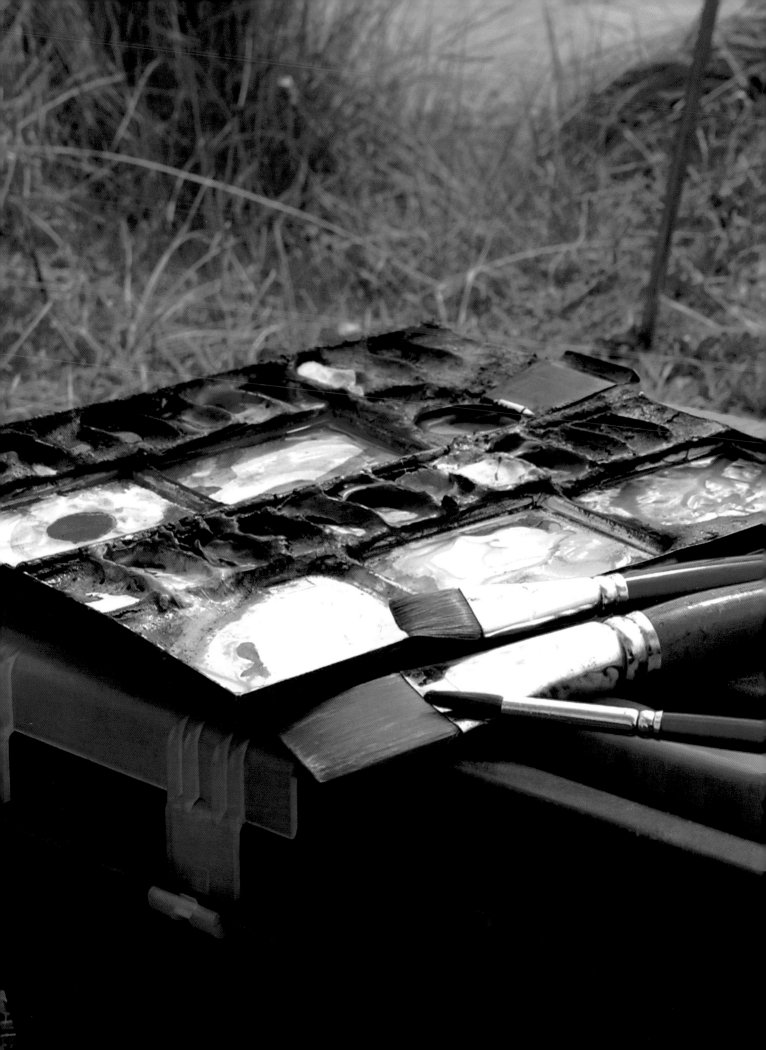

Materials and Equipment

All the materials that I use are made by Daler-Rowney. It's usually the case that you tend to use what your superiors used before you, such as course tutors or college lecturers. So you stick with what you are used to. For me, allied to this is the fact that Daler-Rowney products have an exceptionally long tradition and were always used by the likes of the great J.M.W. Turner – which is good enough for me!

Whether or not you decide to use the same materials as I do, remember that part of the title of this book is 'quick'; the big rule here is not to burden yourself down with all sorts of stuff that you'll never use and that just gets in the way. Use the guidelines I've given in this section, keep equipment to a minimum, and you won't go far wrong.

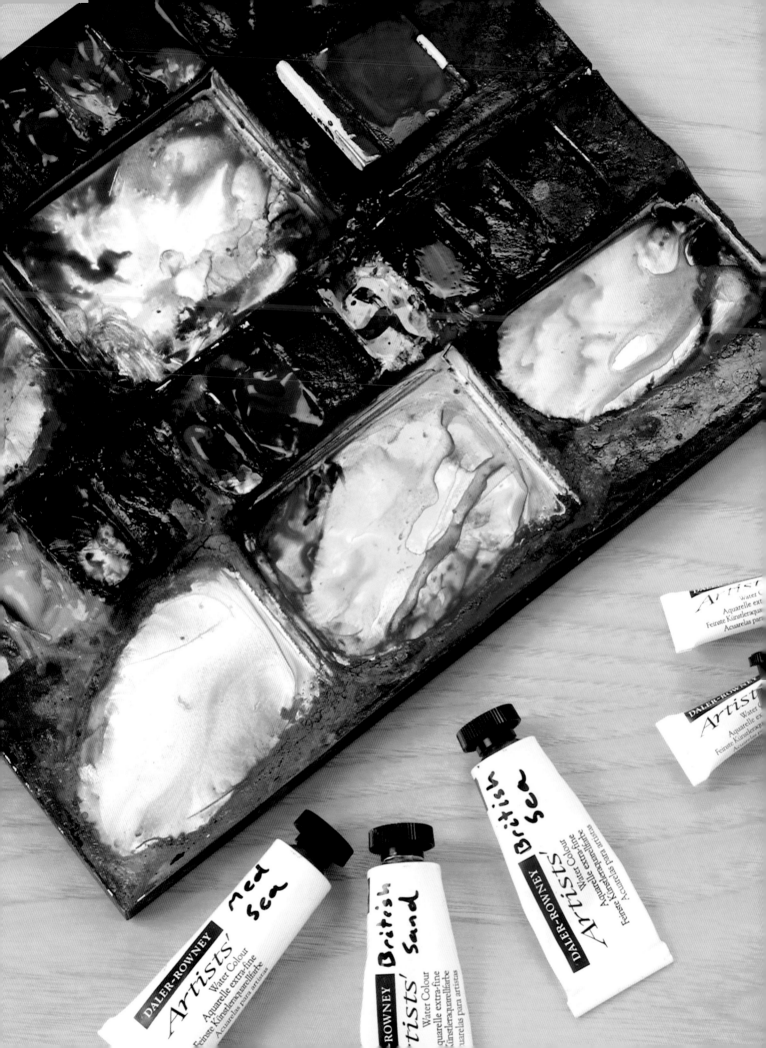

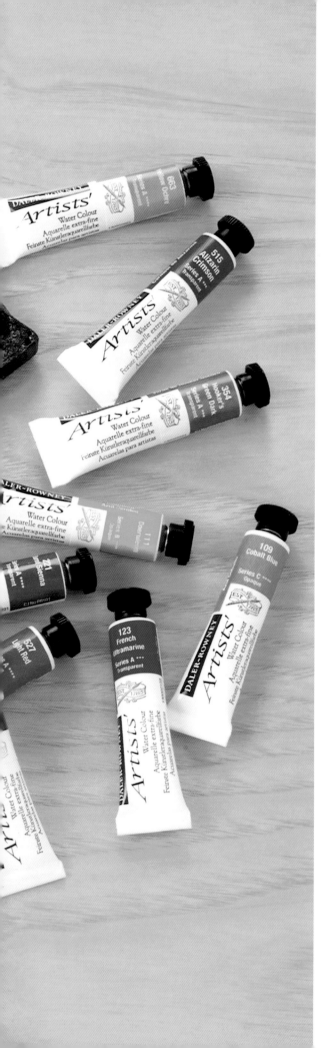

Paint

The paints I use are all artists' quality: French ultramarine, burnt sienna, yellow ochre, raw umber, Hooker's green (dark), cerulean or cobalt blue, alizarin crimson and light red.

Three new paint colours are introduced for the first time in this book, the Charles Evans range: British sea, Mediterranean sea, and British sand, all produced by Daler-Rowney to my specifications. They are ready-mixed colours to make it easier for you to capture the colour of water: you can use them straight from the tubes or play around, mix and match and experiment.

The first two are called sea colours, but if you stick plenty of water in them, especially sea for Great Britain, this will do for any stretch of water, be it a lake or river. If you want to adjust the colour slightly, I would suggest adding a tiny touch of Hooker's green, which will change the colour sufficiently for a beautiful lake type of water that catches a hint of surrounding greenery.

Obviously, as with any other colour, these colours can be stronger or weaker depending on the amount of water added. Sea for the Mediterranean is a beautiful warm colour, and if you want to deepen it ever so slightly, to make it even more warm and strong, add a tiny tint of alizarin crimson – but it's just as good on its own, straight from the tube.

You can warm up the sand colour with the addition of a hint of burnt sienna, cool it down with a tiny touch of French ultramarine, or make it brighter with a similar amount of yellow ochre; for a very neutral beach, just use it straight from the tube.

Another very useful feature of the sand colour is that you can use it for mixing in place of white: when you mix white paint with a colour to make it lighter, you end up with an opaque colour because white is totally opaque – if you use the sand colour instead, its neutrality and transparency will lighten everything without making the mixed colour opaque.

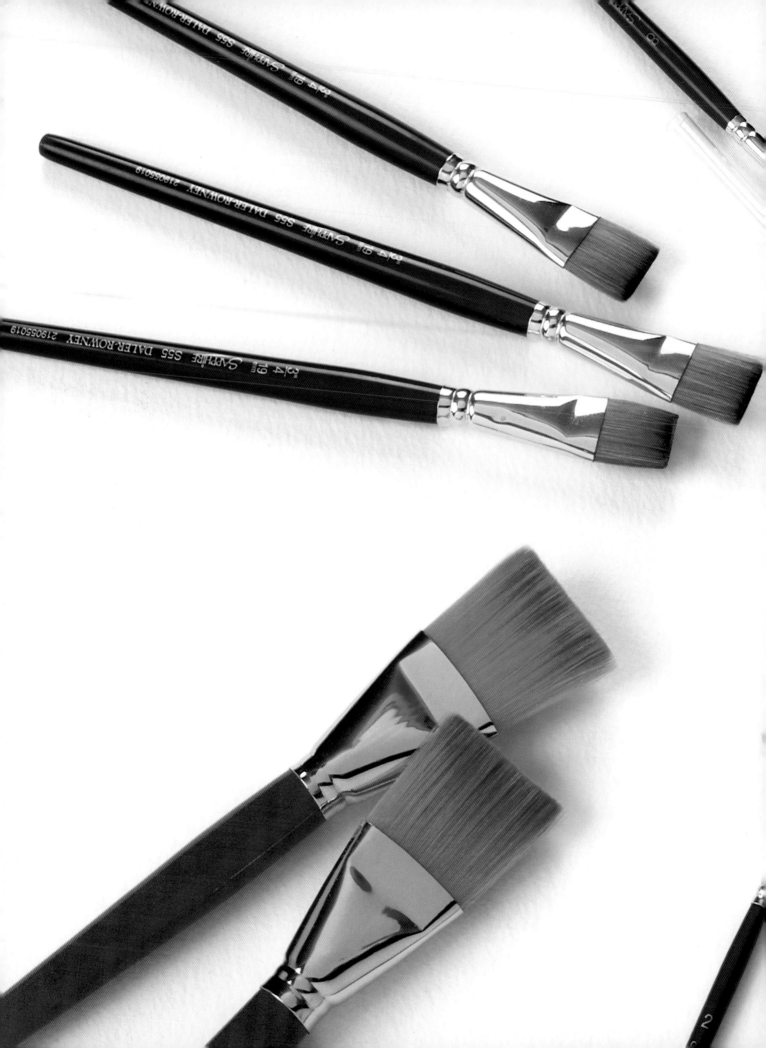

Brushes and Paper

The biggest brush I use is a 1½in Dalon, a totally synthetic brush that has been abused for about the last 10 years. It looks well used and is also bent, bitter and twisted, but it does a really good job. My other three brushes are all Sapphire, which is a blend of best quality sable and synthetic and can thus have the qualities of both kinds of bristle. These are a ¾in flat wash brush, a No. 8 round and a No. 3 rigger.

So you see, I only ever use four brushes in total – there are no great rafts of equipment and brush rolls bursting out at the seams, most of which are never used. If I can't hold it in my hand or keep it in my bucket, then it's surplus to requirements.

The paper I normally use, and have used throughout this book, is Langton Rough. This is only 300gsm (140lb) in weight, and both sides are identical – there's no wrong side, therefore, and you can't really go wrong with it. I never pre-stretch or mess about with the paper; I just chop a sheet in half and tape it to the board using ordinary masking tape.

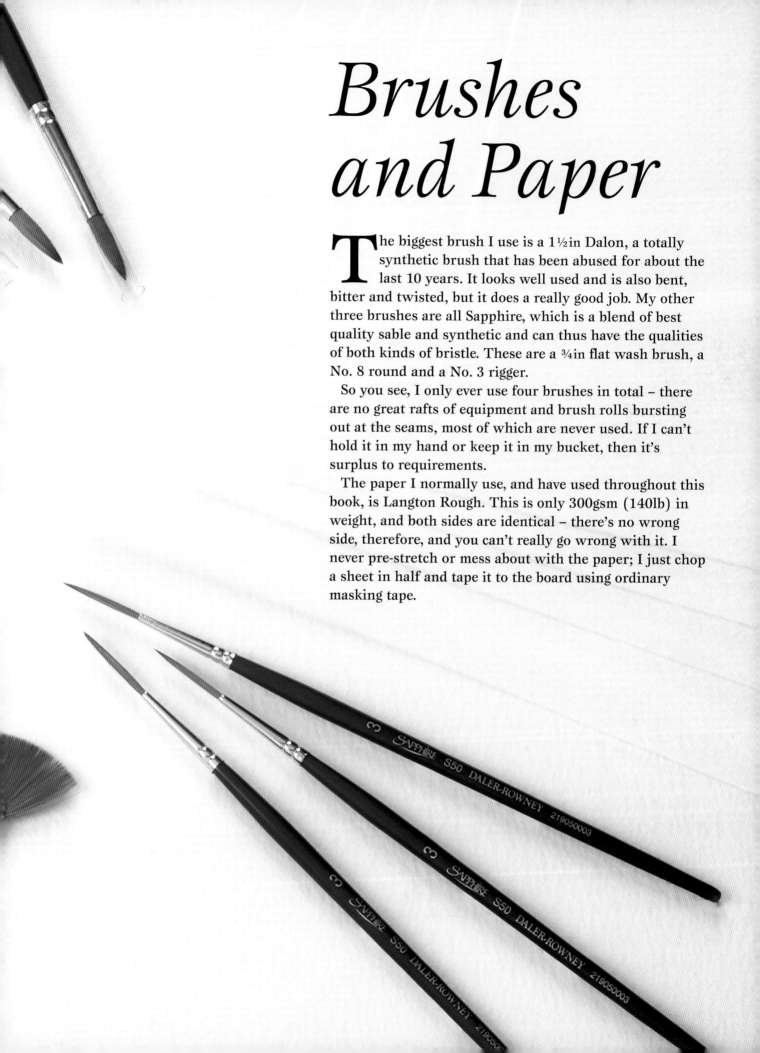

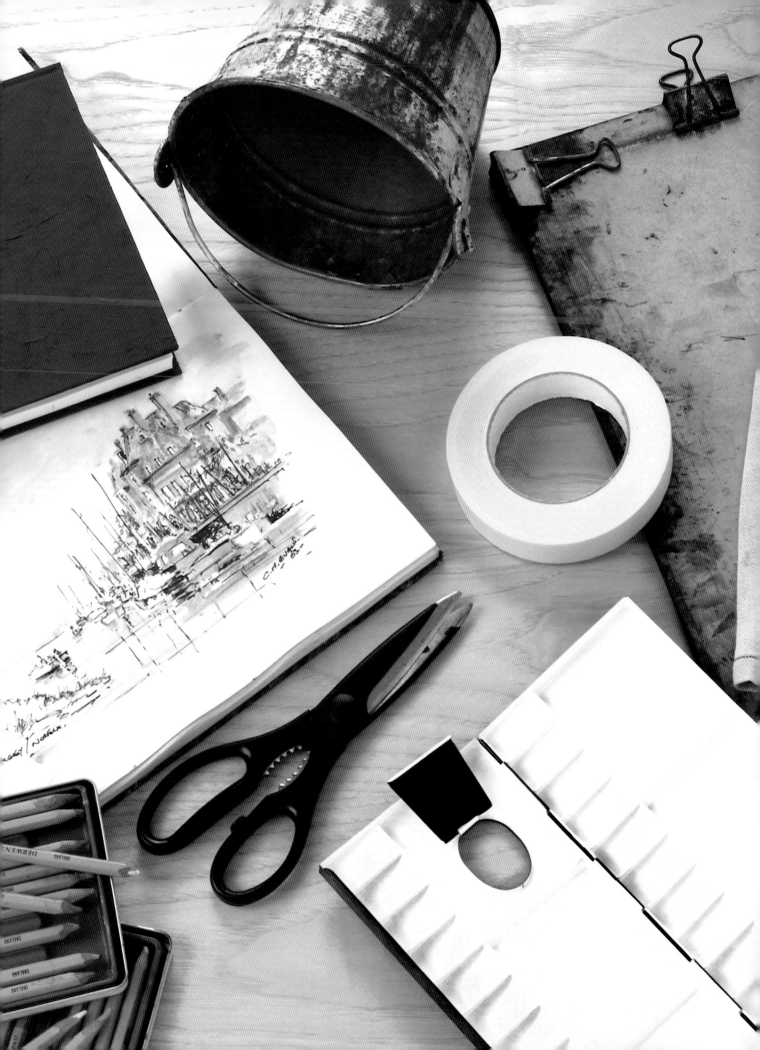

Other Materials

The 'lead' pencil that I use can be anything – basically, whatever I can nick from my nephew's chalkbox – because there is never, ever going to be be crosshatching or shading; I always just use a simple outline. The only time I do use fancy pencils is when I'm doing outdoor sketching, and for this I use a selection of Derwent watercolour pencils (see page 81).

My easel is a Westminster easel, which is metal. It is good and sturdy, and is well equipped to handle the rigours of airport luggage handlers. When I'm out on location and the wind is blowing, I simply pull out the rubber plugs at the bottom of the legs and whack the legs into the ground.

I use a hardback sketch book, A4 size. I stress the 'hardback' bit because the books are properly string bound, and therefore the pages don't fall out, no matter how much they are bashed. I always carry a penknife, because I never sharpen my pencils with a pencil sharpener.

My board is no more than a piece of MDF, smoothed and rounded at the edges. I use ordinary masking tape to stick the paper to the board.

And that's it – now let's get on with some painting!

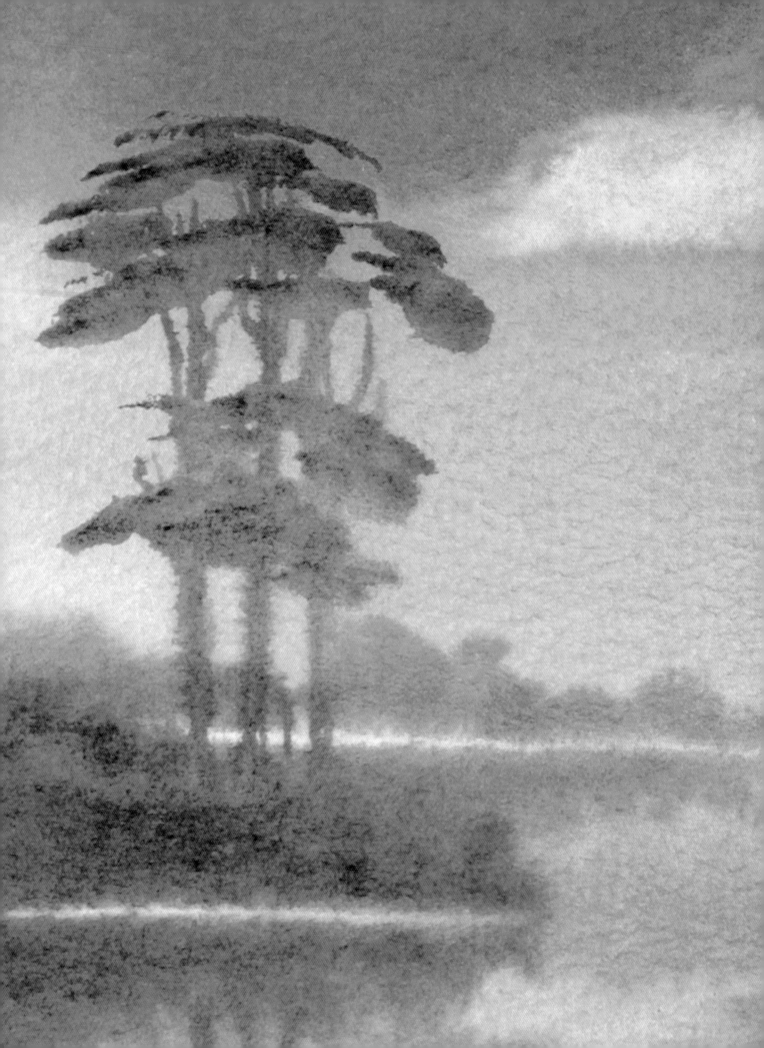

Trees and Lake

This first project introduces my key ideas on
painting: keep paints and brushes to a minimum,
work fast and concentrate on the big picture.

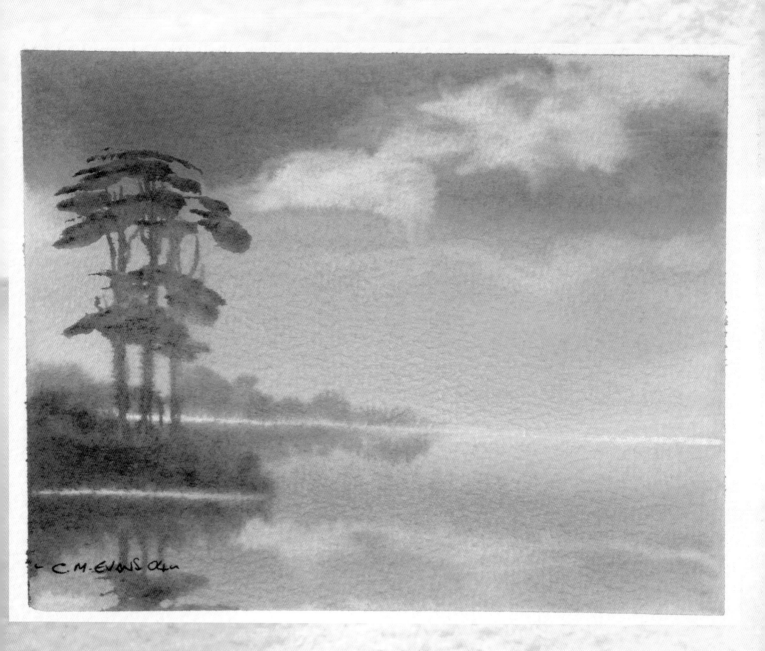

Ideally, this little study should only take a few minutes to do. I used a limited number of colours, and I used the same mix for several parts of the painting. Most importantly, you should think about the overall picture all the time – don't get worried about whether anything is absolutely accurate or right, but work quickly and confidently.

1 To begin, I use a large flat wash brush to wet the whole of the paper, then squeeze out the brush and add a line of yellow ochre across the middle.
2 I add burnt sienna above and below the ochre, and above and below that, a mix of French ultramarine with a tiny touch of burnt sienna. I mop up the bottom of the picture, squeeze the brush out and merge the colours.
3 After rinsing and squeezing out the brush, I draw out the pigment in the sky for clouds, and repeat this in the water for a reflection.

4 Using a really wet mix of French ultramarine and burnt sienna and a No. 8 round brush, I wipe the brush straight across the picture so that it spreads – bleeding of pigment is normally my worst enemy, but I can take advantage of it now. I repeat this in the water for the reflection of the trees in the distance. To make a difference between the water and the sky, I use the ¾ in wash brush and clean water to suck out pigment in a line across the picture.

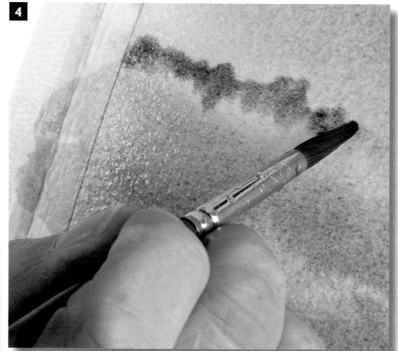

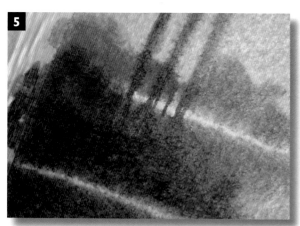

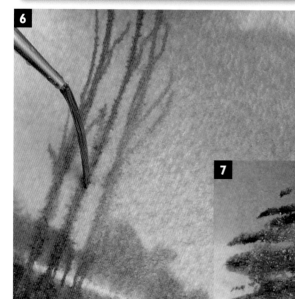

5 For the bushes, I make a watery mix of Hooker's green and burnt sienna, drop this on to the paper so that it spreads, and repeat below the dividing line. I then drop a mix of French ultramarine and burnt sienna into the green of the bushes to make shadows, and again repeat this, pulling out the colour in the reflections with the wash brush.

6 I now switch to a No. 3 rigger brush and use raw umber to make a couple of trees with their branches, repeating this for the reflections.

7 Returning to the round brush and the Hooker's green and burnt sienna mix, I dab on sharp-edged marks to make the foliage of the Scots pines. And that's it – the work only took me a couple of minutes to do, but it looks fine.

EXERCISE
SKIES

Whether it's a flat, open prairie or a crowded town scene with high buildings, any landscape needs to have an effective, convincing sky. The exercises here show you some quick and clever ways to paint skies.

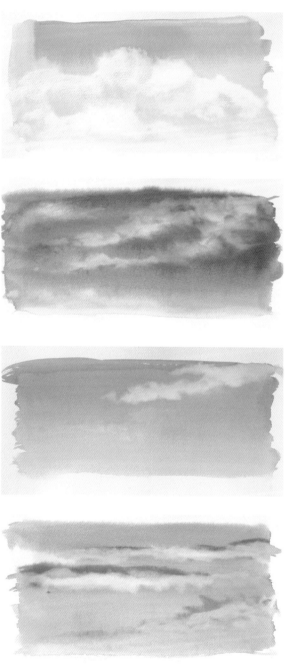

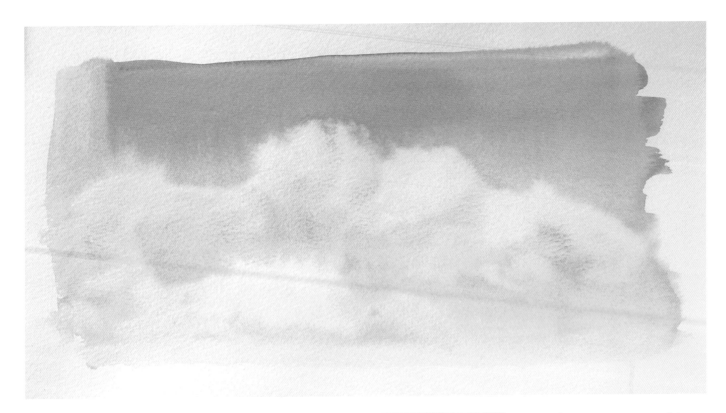

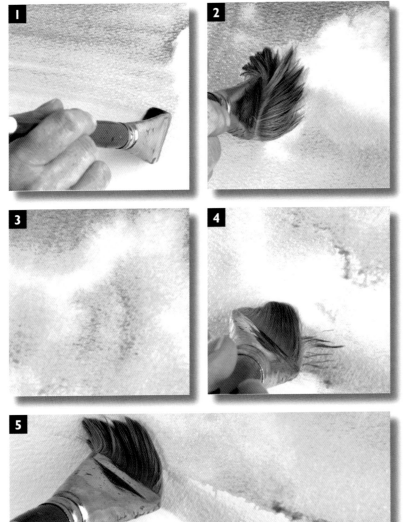

It's important to get this exercise done in less than five minutes – two or three is ideal, as beyond that the paper will start to dry, and taking pigment out of drying paper results in sharp edges.

1 Wet a rectangle of paper with a large flat wash brush, then stroke a watery wash of French ultramarine over the whole piece of paper.

2 Rinse out with water, then squeeze the brush until it's slightly damp, then use it to draw the pigment off the paper to make cloud shapes.

3 For the cloud shadows, drop a very watery mix of French ultramarine and light red into the bases of the clouds.

4 Draw out the pigment as before to soften the edges.

5 Wet the brush with a little clean water and squeeze most of it before mopping out the bottom line. There you go.

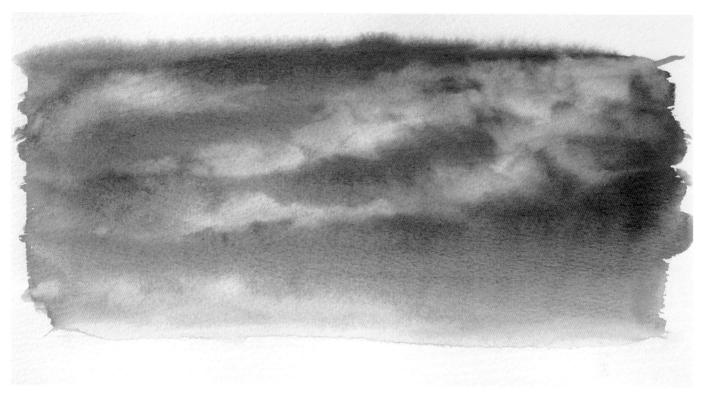

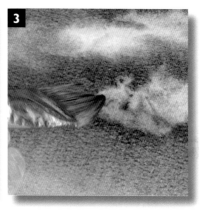

You should run if you see a sky like this! I use a brush to draw out pigment for two reasons: first, it gives a softer edge than can be got from a kitchen roll piece or sponge, and second, it means I don't have to carry lots of extra gear around with me. Using the brush also leaves some of the underlying colour in place.

1 Using a flat wash brush, wet the entire area and stroke yellow ochre across the bottom third of the paper. Follow this with burnt sienna on the middle third and a mix of French ultramarine and burnt sienna from the top, all the way through the other colours, so as to avoid sharp joining lines – the other colours will still shine through. Remember that

the colour when dry will be 50 per cent lighter than when it is applied, so don't worry about going in too dark.

2 Make up another mix of French ultramarine and burnt sienna, with more sienna. Paint this into the sky while the other washes are still wet.

3 Wash and squeeze out the brush, and draw or suck clouds from the wet washes.

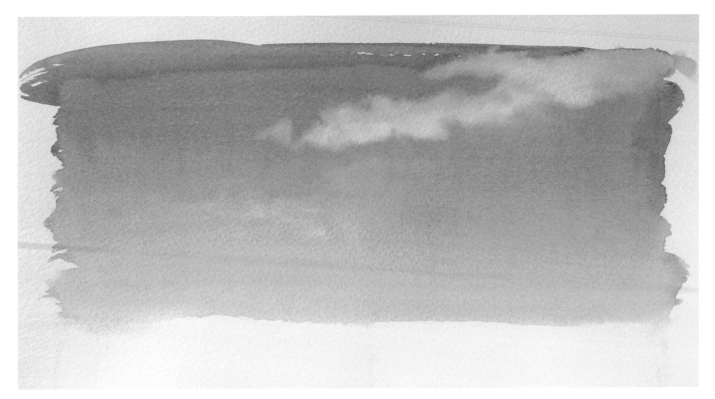

In a way, a neutral sky is almost more of a challenge than the other types seen in these exercises – nothing is happening here, so you need to get what is there down well on the paper.

1 Using a large flat wash brush, wet the paper with clean water and then put a mix of yellow ochre and alizarin crimson across the bottom of the sky. Next, stroke a mix of French ultramarine and light red from the top of the sky all the way down through the first wash; don't stop when the colours meet, but work over so you can see the reddish wash underneath the second one.

2 As for the other exercises, wash and squeeze out the brush and draw out the pigment at the top, to give an impression of a quiet sky with few clouds.

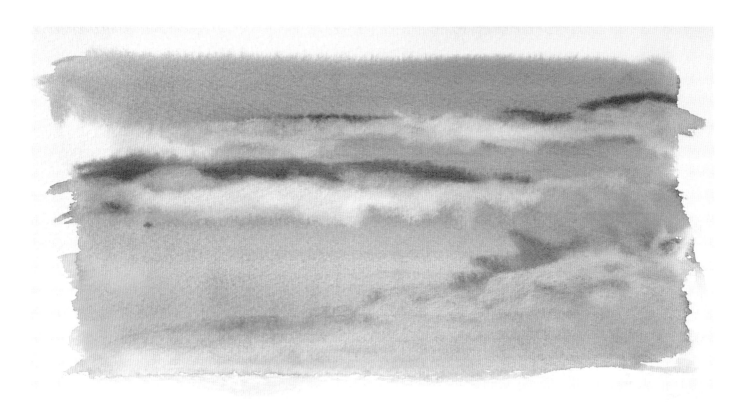

Here's a tip: in a sunset sky the sun has already gone over the horizon, so you should take the pigment out from underneath the clouds.

1 After wetting the paper, put a stroke of yellow ochre across the bottom and another in the middle. Add some light red – this is a powerful colour, so be careful when you use it.
2 Start painting a mix of French ultramarine and burnt sienna from the top, but leave little bits of underlying colour showing to provide the sunset glow.
3 Add more burnt sienna to the mix to darken it, and put in a few sharp bits of darker cloud.
4 Use a cleaned brush to draw out the cloud shapes.

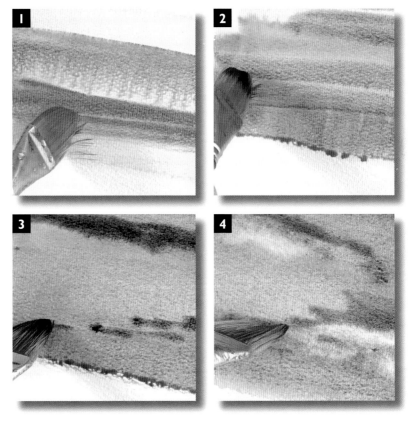

EXERCISE **SUNSET SKY**

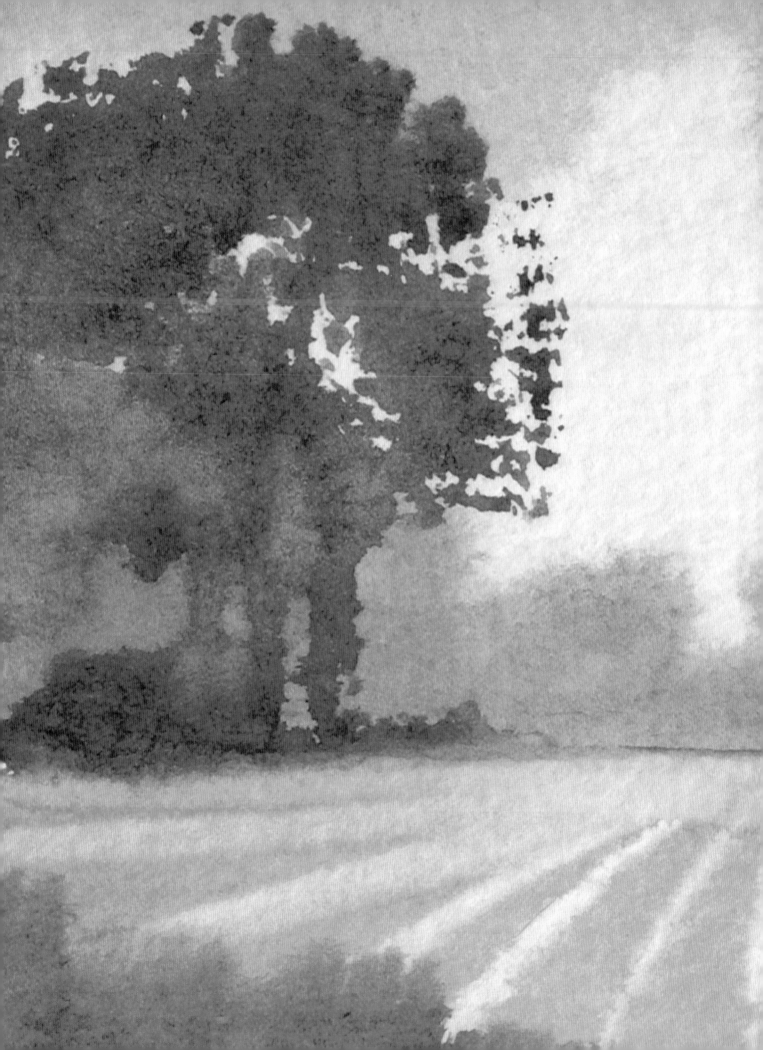

Cornfield

This golden view sums up summer in the country
– you can almost feel the heat. The project uses
just one brush, to keep things as simple as possible.

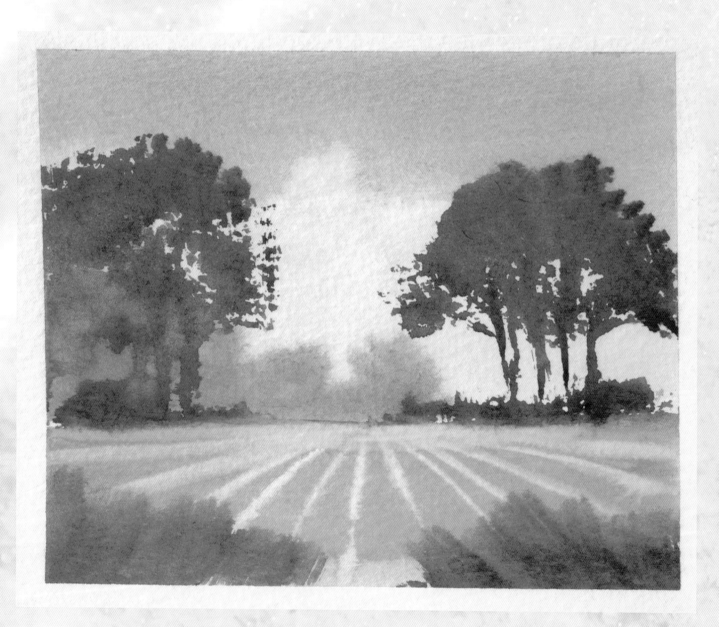

In addition to using one brush only, I decided not to do any preliminary drawing for this project. The combination fine-tunes your brushstroke skills and you get to find out what your single brush can do. Try to limit yourself to about 10 minutes here, because you have to work quickly to finish.

1 Using a ¾in flat wash brush, I start by wetting the sky area – about two-thirds of the picture – with clean water. I then apply a first wash of watery French ultramarine across the top.

2 I then continue down the paper, using more water and less paint each time. This is known as a graduated wash – but I call it slapping it on quick!

3 After rinsing and squeezing out the brush, I use it to draw out the wet pigment to make cloud shapes.

4 Using clean water, I mop along the bottom edge.

5 While the sky is still very wet, I add a touch of burnt sienna to French ultramarine to make a darker blue, which I then dab into the horizon.

CORNFIELD

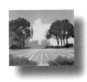

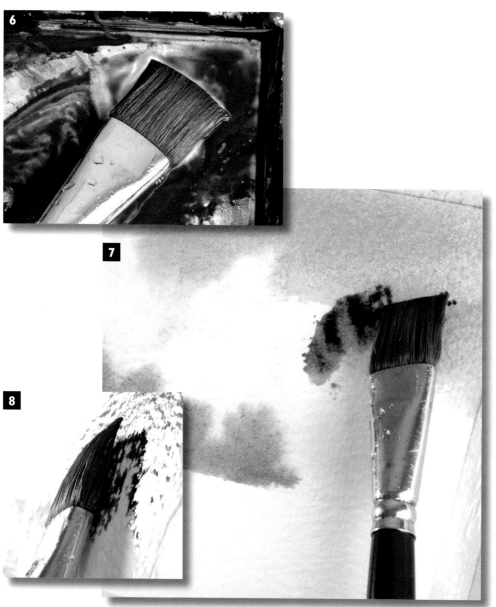

6 For the foliage, I make up a mixture of Hooker's green and burnt sienna, which I keep strong but watery. I dab the brush into the mix, thus loading the hair with lots of paint.

7 To start the foliage for the foreground trees I tap the hair of the brush on to the paper, where it picks up on the rough-textured surface.

8 I make sure the metal of the brush also taps on to the paper – this guarantees that the whole length of the hair is slapping on the paper.

9 The result is a mass of green leaves, but not a solid one, that still has some of the sky colour showing through. As the paint dries, it will show darker and lighter clumps of foliage.

Top Tip

WHEN IT COMES TO PAINTING TREES, UNLESS YOU ARE A BOTANICAL ARTIST, IT'S BEST TO CONCENTRATE ON PAINTING FULL FOLIAGE AS A MASS, NOT ON THE INDIVIDUAL LEAVES.

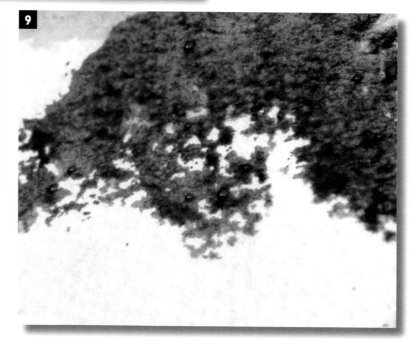

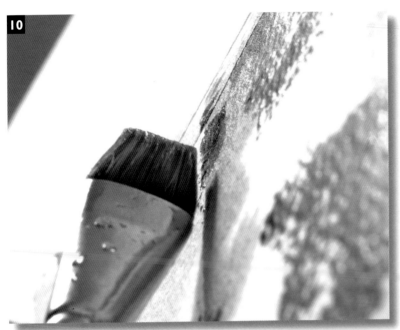

10 To add liveliness to the foliage, I also use the side of the brush to flick upwards into the greater mass of leaves.

11 I then use the end of the brush hair to create the trunks and large branches. I call this bit 'joining up the dots'.

12 With the brush thoroughly cleaned, I load yellow ochre on to it and make one broad stroke across the paper below the trees, and clean and squeeze out the brush to remove a band at the very bottom – I don't take out too much pigment here, however.

13 This time I squeeze out most of the water and use the end to draw out pigment to make the spaces between the rows of corn.

Top Tip

I USE DOUBLE LAYERS OF ORDINARY MASKING TAPE TO STICK THE PAPER TO THE BOARD. (YOU CAN ALSO USE WIDER TAPE RATHER THAN TWO RUNS.) HOWEVER, I NEVER USE THE BROWN 'LICK AND STICK' TAPE: FOR A START IT DOESN'T EVER PEEL OFF PROPERLY, AND IT TASTES AWFUL!

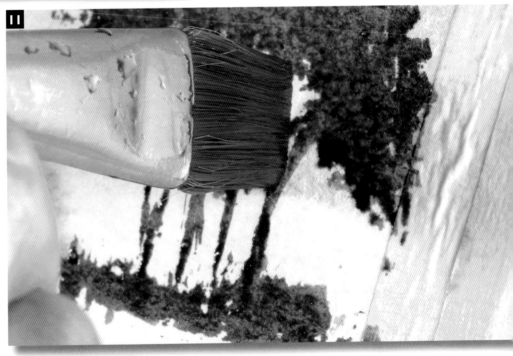

CORNFIELD

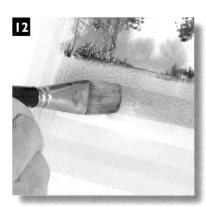

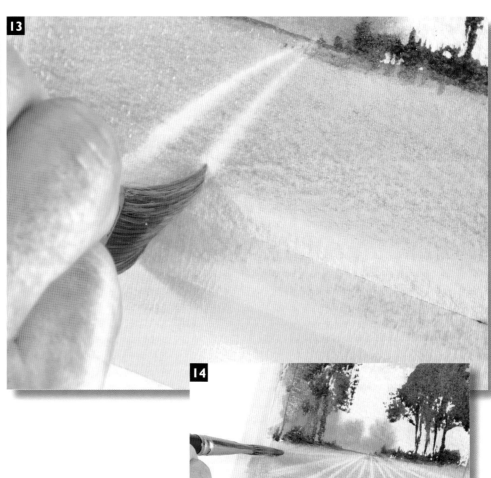

14 As I add the lighter rows, I squeeze out the brush every few strokes to make sure I remove the pigment, not just move the paint about.

15 Now I make up a light green from Hooker's green and burnt sienna, and add a few flicks of this into the very foreground.

16 When I push the brush upwards the hairs split apart to give me some blades of grass. I peel off the tape, and there's my picture – not bad!

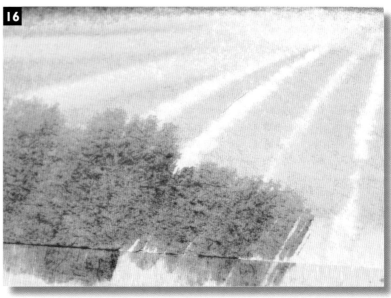

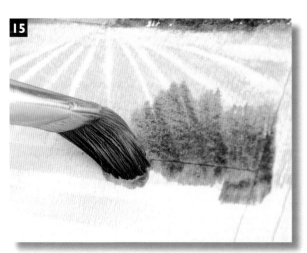

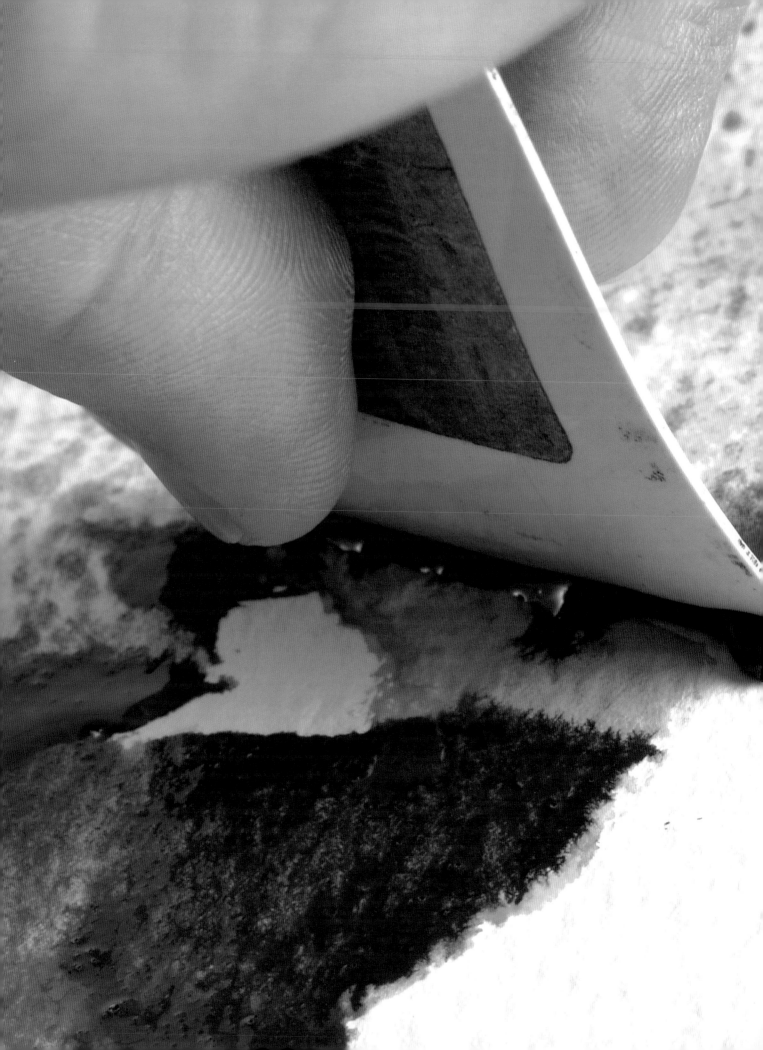

EXERCISE
BOATS AND ROCKS

Although you can sometimes get away with a straight view of the sea, with no other features, there will undoubtedly be times when a bit more interest is needed. Here's how.

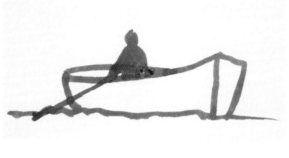

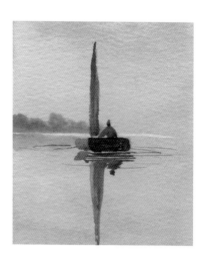

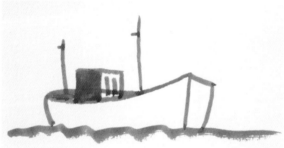

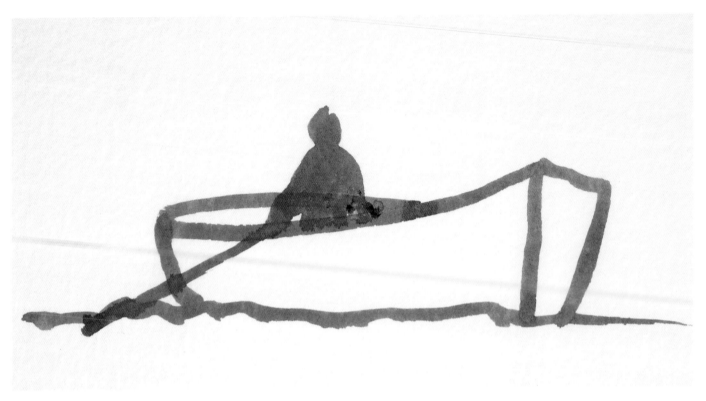

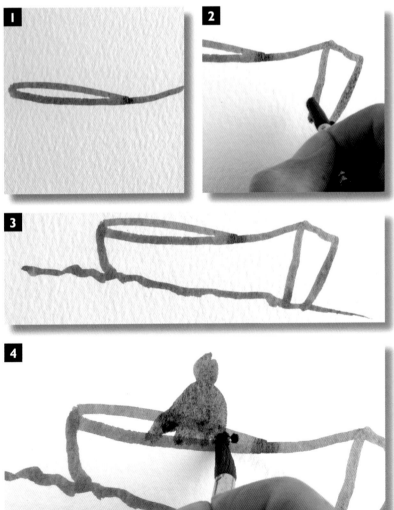

What worries many people is painting the front end – the pointed shape – so they tend to put the boat sideways on. If you use a 'fish shape', it becomes easy to make a basic boat.

1 Paint most of the shape of a thin fish, but don't finish the lower tail line.

2 At the end, make an irregular rectangle without the bottom line that closes the box.

3 A light, squiggly line to make the sea, and you have an effective simple boat.

4 One round blob for the head, an elongated one for the body and another one for the arm and even an oar, and there's your rowing boat.

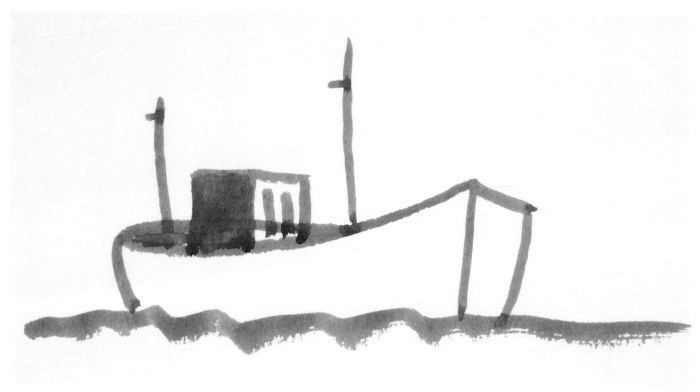

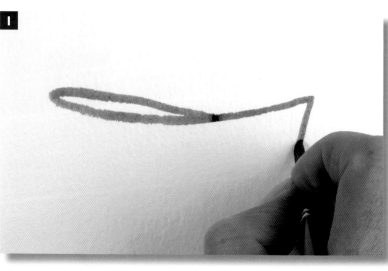

1

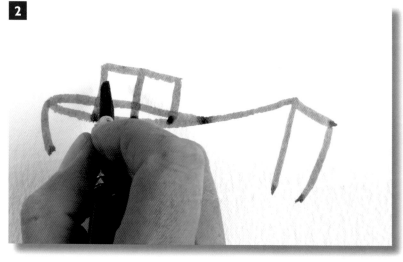

2

Once you get used to working with the fish shape to start your boats, you can then expand your repertoire with just a few simple strokes of the brush. Here's a fishing trawler to give you an idea.

1 With one flowing brushstroke, paint the fish shape, this time bringing the 'tail' up and then down at the end corner.

2 Stick a box on top, making sure that the box corners are correct for the angle at which the boat is to your view. Add a couple of simple strokes for windows, block in the box side, then put in a couple of masts and a lapping sea line, and that's the trawler done.

EXERCISE **TRAWLER**

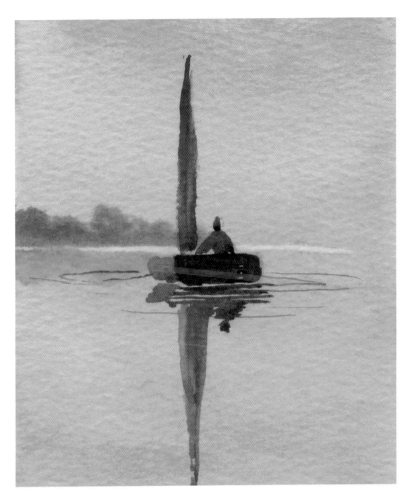

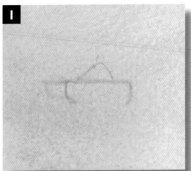

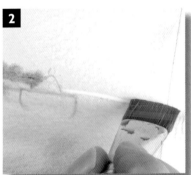

In this exercise, I make the sky and water all in one, as on p14–17. There is a bit of drawing to give you some clues: a horizon line (sky and water) with a couple of rounded bits for the boat and a triangle on top for the figure.

I Wet all the paper, and wash light red across the middle, and a mix of French ultramarine and light red at top and bottom. Draw out the clouds and leave to dry a bit.

2 Drop in a darker version of the mix, stopping at the boat, then draw out a separation line in the middle of the picture and leave to dry fully.

3 Use a fairly strong mix of raw umber and burnt sienna to make burnt umber for the side

of the boat, and a lighter version for the sides and reflection, which is in strands, not solid.

4 For the sail, use light red, and repeat underneath lighter for the reflection.

5 Add the shadow-side of the sail in a mix of French ultramarine and burnt sienna, darker than the trees, and use the same mix for the reflection and the figure in the boat. Finish with a few ripples.

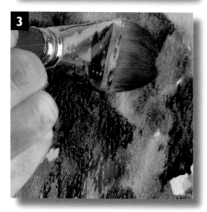

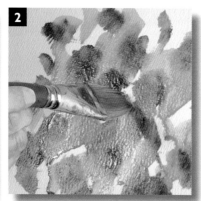

You can go into detail when painting rocks, but this takes up a lot of time. My way uses few colours and a credit card – if you want smaller rocks, cut up the card, which will save you money as well!

1 Use a flat wash brush to dab on light marks of yellow ochre.
2 Wash the brush and, while the ochre is wet, add mid-tone colours using raw umber.
3 Make a black from French ultramarine and burnt sienna and add this, leaving some patches of white on the paper.
4 Scrape the credit card over the wet paint to create a clump of individual rocks; don't be loose with the card, but dig it in. And there are your rocks!

EXERCISE ROCKS

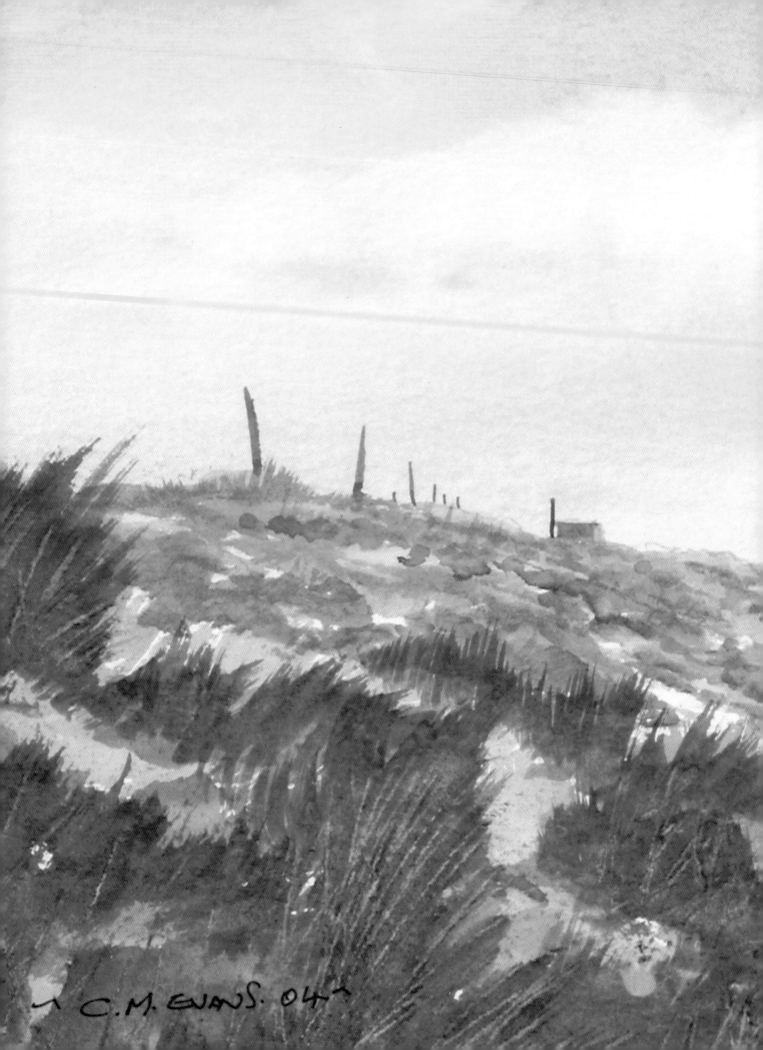

C.M. EVANS. 04

Seascape

The combination of open sea and big sky is an
irresistible one. You don't need to work on details
here, but can concentrate on getting the mood.

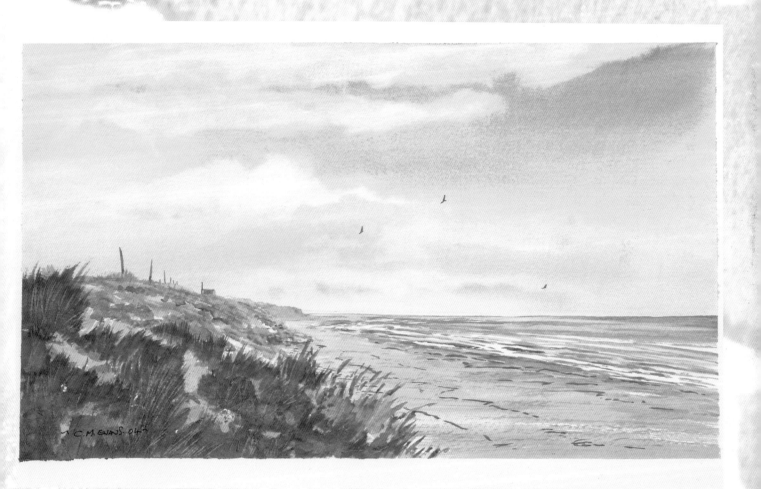

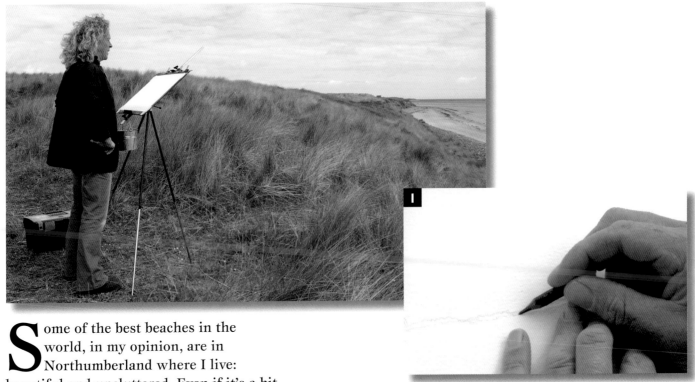

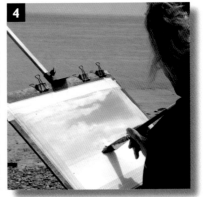

S ome of the best beaches in the world, in my opinion, are in Northumberland where I live: beautiful and uncluttered. Even if it's a bit cold and windy, a day where the light is not too bright is perfect for painting, as you can see what you're doing – on a glorious sunny day, you can't see anything for the brilliant white paper.

1 The most important line is the sea line: this doesn't have to be perfectly straight, but it mustn't be wobbly. To get a straight line, I draw against another piece of paper – no problem!

2 I use seawater to wet the sky area with a 1½ in wash brush, and then apply a wash of alizarin crimson and yellow ochre at the base, then French ultramarine above, blending the paint together.

3 After washing out the brush and squeezing out the water, I use it to suck out the paint along the

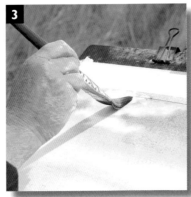

SEASCAPE

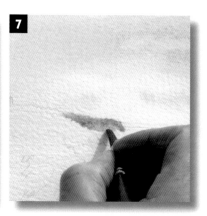

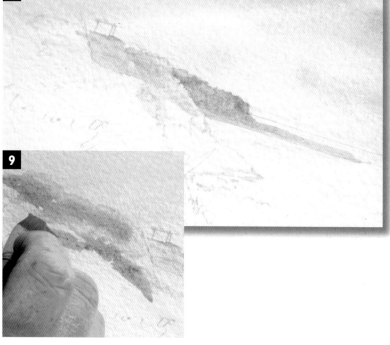

bottom line and take off the paint for the clouds. The idea here is to work fast before the paint dries, and to sum up the feel of the sky, not chase the clouds – they'll always win.

4 In the sky I drop in some French ultramarine mixed with a little light red for more clouds, then rinse and squeeze the brush again and use it to take out the excess at the bottom. I now let the painting dry; any flies that get stuck to it can become birds in the picture later.

5 When everything is completely dry, I start on the sand dunes on the distant headland, putting on a mix of French ultramarine and light red very loosely with a No. 8 round brush.

6 While this wash is still wet, I add a tiny bit of yellow ochre below it.

7 I clean the brush in water, squeeze it until it's just a bit damp and quickly merge the two washes together to create a nice soft edge.

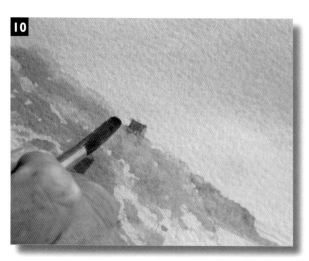

8 I put in a weakish wash of yellow ochre for the next hill on the left.

9 While this wash is still wet, I drop in a mix of Hooker's green and yellow ochre so that the colours merge, leaving no hard edges. I then add slightly weaker mixes further into the distance.

10 I use French ultramarine with a tiny bit of light red for the distant building – which is an old coastal defence bunker – putting more water into the mix for the side edge and making it darker in the shadows. I then let everything dry completely.

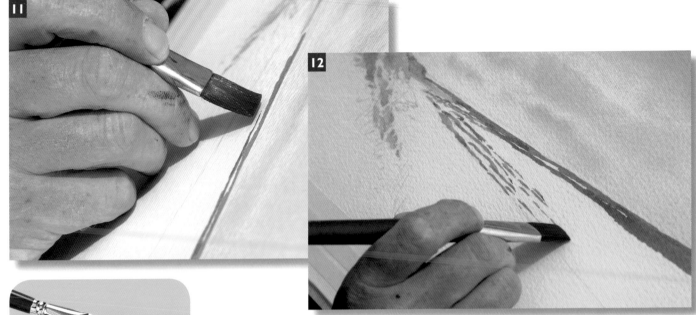

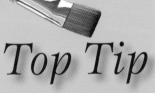

Top Tip

WHENEVER YOU NEED TO LET WASHES DRY BEFORE CONTINUING, USE THE TIME TO CHANGE THE SEAWATER IN YOUR BUCKET – THE WALK WILL DO YOU GOOD, AND YOU CAN COME BACK TO LOOK AT THE PAINTING AGAIN WITH A FRESH EYE.

11 Now it's time to start the sea, using my Charles Evans British sea colour – this can be used as a base colour for mixes, but today I'm using it as it comes. Switching back to the ¾in wash brush, I start with the horizon line.

12 As I get nearer to the the headland and beach, I just tap the brush on to the paper, then add a few squiggly lines the closer I get to shore. At this stage I leave a lot of white paper between the brush marks for highlights.

13 As before, I wash and squeeze out the brush to pull out paint for the ripples in the waves, and let the painting dry again.

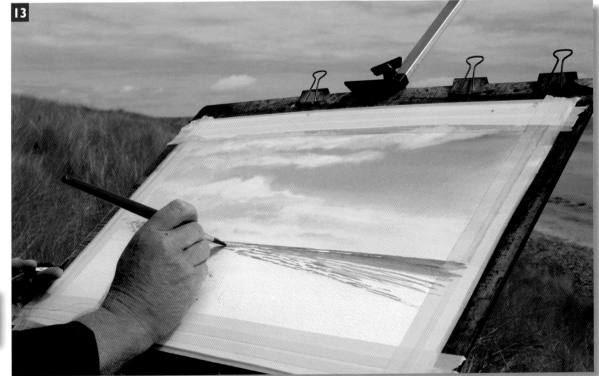

SEASCAPE

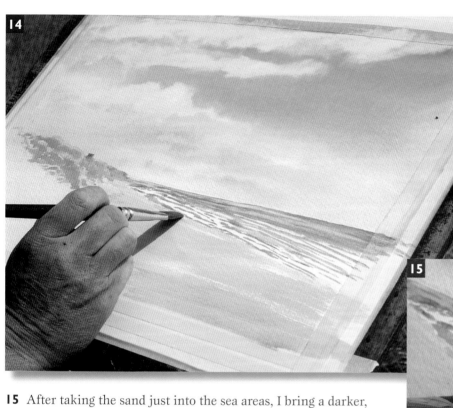

14 With everything dry, I make up a mix of the Charles Evans sand colour – this is also a useful colour for lightening mixes, while not being opaque like white paint. This time I use it as a base colour, adding a little French ultramarine and a lot of water, then make wide strokes to block in the basic colour of the sand. (On warmer beaches, I might use tiny amounts of yellow ochre or burnt sienna.)

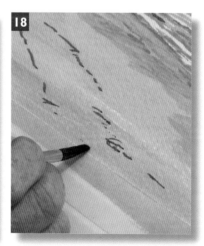

15 After taking the sand just into the sea areas, I bring a darker, but still watery, wash of the sea colour over the sand. I then reinforce the very light sea washes, still leaving plenty of white highlights on the paper.

16 Switching to the No. 8 round brush, I mix the sand colour with some raw umber for the stones in the middle distance – I'm not trying to paint every single one, but to give an impression of the lines and shapes of the stones.

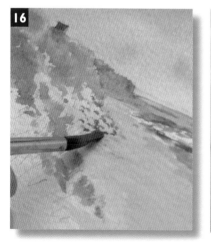

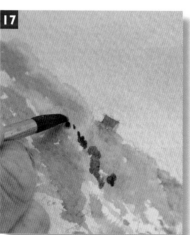

17 I use a mix of French ultramarine with a little light red and plenty of water to paint some dips and gullies in the sand dunes among the grasses. As in any painting, these darker touches make the most of the lighter areas around them.

18 For the smaller touches on the beach – the darker patches of sand, strands of seaweed, stones and pebbles – I use a darkish mix of French ultramarine and burnt sienna.

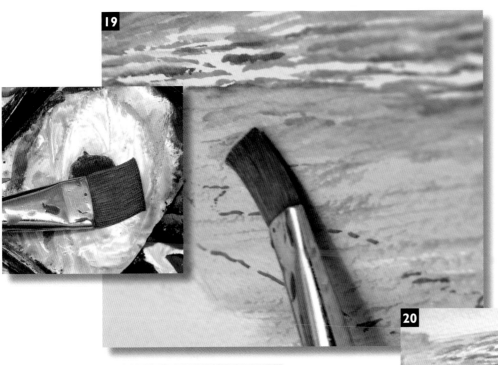

19 Using the same mix as for step 18, only this time going back to the ¾in flat wash brush, I lightly brush over the surface of the paper to create a sparkling texture on the sand.

20 Switching back to the No. 8 round brush, I then add some more dark areas in the sea and along the shore line.

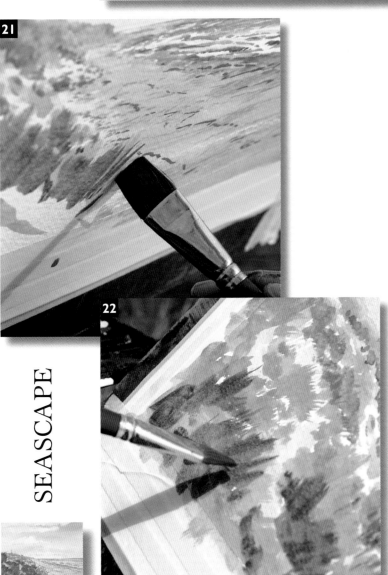

21 I now make up a warmish mix of the Charles Evans sea colour and yellow ochre, and paint this into the nearest sand dunes with the ¾in flat brush. I flick the brush up to go into the darkest areas here, and then use a mix of Hooker's green and yellow ochre in the same area – again, I flick up into the yellow for tall, windswept grasses, being careful to leave white highlights.

22 In the foreground I paint on a mix of Hooker's green and burnt sienna – because the colours will dry up to 50 per cent lighter than when applied, I use quite a strong mix.

SEASCAPE

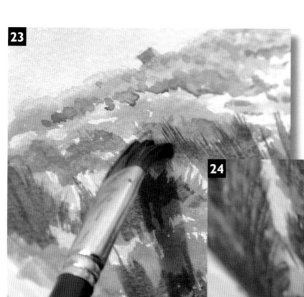

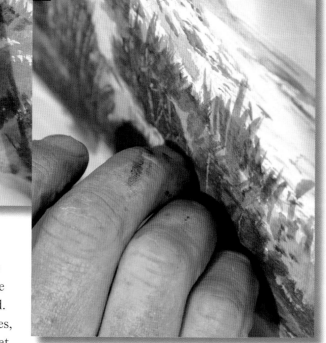

23 I now make up a mix of French ultramarine and light red with lots of water, and use this to go even darker on to the dune grasses in the foreground. As well as the flat of the bristles, I use the side of the brush to get the effects I want – it's worth experimenting with all angles and all parts of the brush to see what you can do.

24 While the wash is still wet. I scratch into the paint with my fingernails to give the impression of light and stalks without trying to get in every single one.

25 Using the mixture from step 23, I switch to a No. 3 rigger brush to put a few seagulls in the sky and a few vertical marks in the far distance, making sure that these are smaller the further away they are. I finish by taking off the tape – and there's the painting!

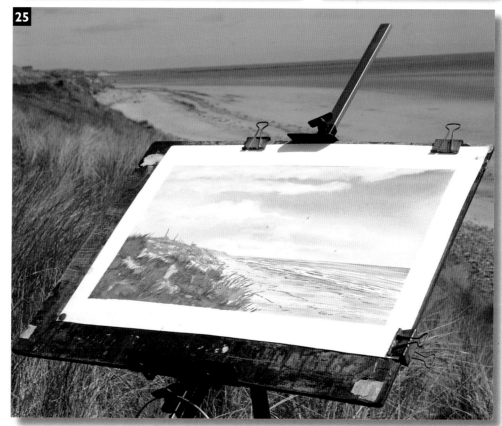

EXERCISE
TREES IN WATERCOLOUR

It's almost traditional for trees to cause all sorts of problems, but the following pages show you how to get quick and clever results with watercolour paints.

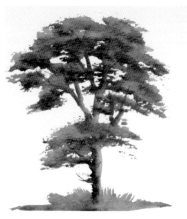

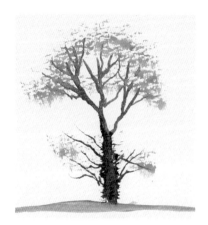

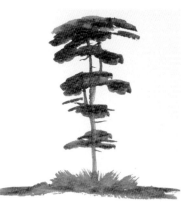

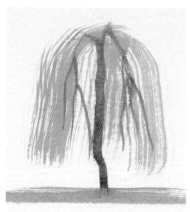

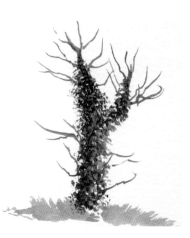

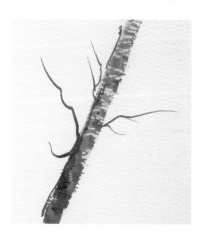

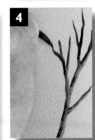

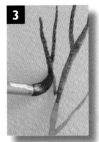

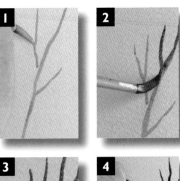

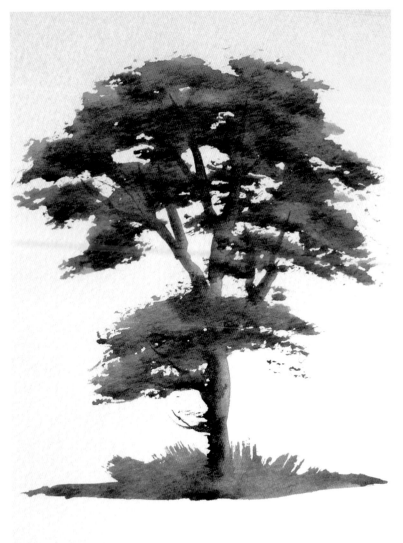

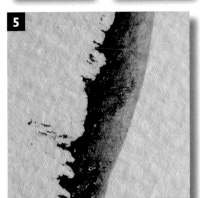

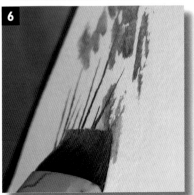

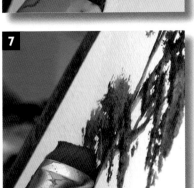

EXERCISE TREE IN DETAIL

This tree may look quite complex, but it is not difficult. Remember to leave gaps through which you can see light and birds can fly.

1 Using a No. 8 round brush, make simple outlines of trunk and branches in yellow ochre.
2 While this is wet, with the same brush put raw umber on the shadow side, opposite to where the light is coming from.
3 The colours run into one another, so there are no hard edges where they meet. This gives a rounded effect.
4 Add a mix of burnt sienna and French ultramarine for a few twigs.

5 To create the impression of rough growth, flick out from the trunk with a No. 3 rigger brush and using the same mix, which adds detail.
6 Now for the canopy of foliage. take up yellow ochre with a ¾ in wash brush, and tap it on from the brush side, then do the same with a mix of Hooker's green and burnt sienna.
7 For the shadow areas, tap on a mix of burnt sienna and French ultramarine blue.

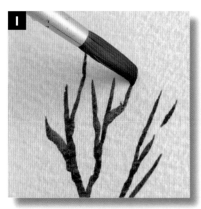

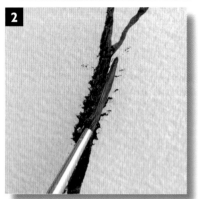

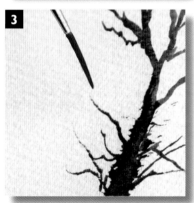

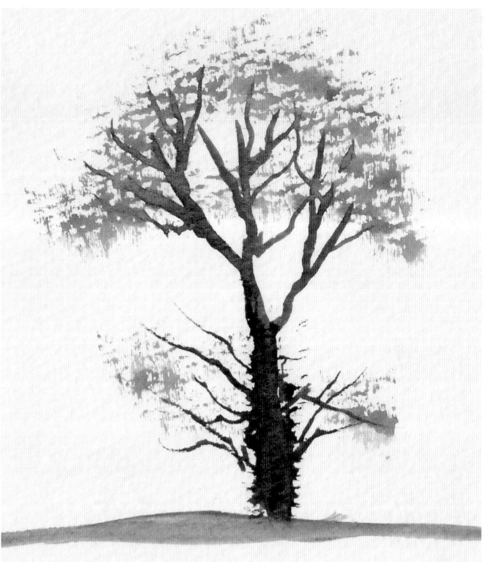

Even though there is hardly any foliage here, the temptation is just the same as for trees with a canopy of leaves: to paint more than you actually need to.

1 Using the No. 8 round brush, make a simple outline of the main trunk and boughs with a mix of French ultramarine blue and burnt sienna.

2 Switching to a No. 3 rigger brush, add a bit of rough on the side by holding the full length of the brush head against the trunk and flicking out. The surface of the paper catches some of the paint and creates a drybrush effect.

3 This time using the tip of the rigger brush and the same wash, add a few twigs – don't go mad trying to add thousands of twigs, but keep it simple.

4 It's again much better to create an impression of a little winter foliage, so take the French ultramarine blue and burnt sienna mix on the ¾ in wash brush and very lightly tap this. And there you are – a stark winter tree!

EXERCISE WINTER TREE

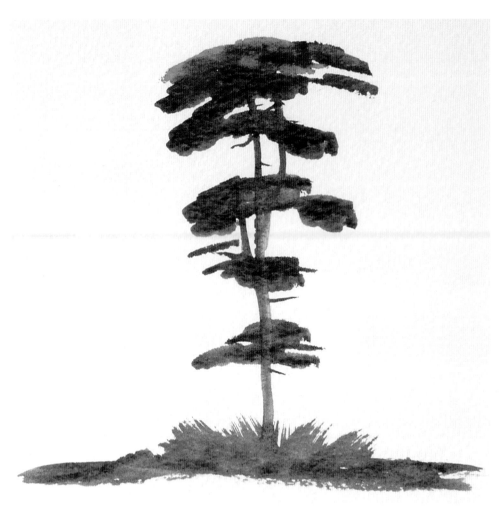

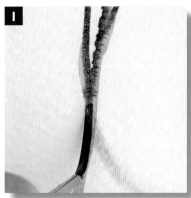

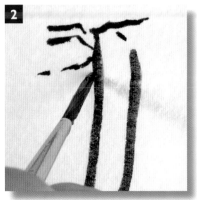

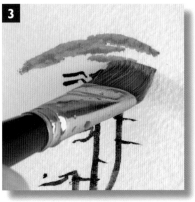

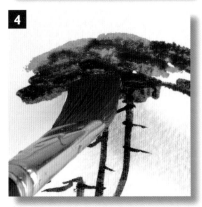

With its upright, strong outline, this is a powerful tree in any landscape. If you stick a few Scots pines in your landscapes, you are bound to add drama and shape; even better, they are simple to paint.

1 Take some yellow ochre with a No. 3 rigger brush and paint the trunk of a tall, slim tree – you can add as many boughs as you like, so long as the trunk shape isn't changed. While the first wash is wet, paint a mix of French ultramarine and burnt sienna down the side of the tree opposite the light.

2 Now for a technical term: use the second mix to add some squiggly bits on top, then move down the tree.

3 Next switch to a ¾ in wash brush and load this with yellow ochre. Add dabs with the flat bristles for the foliage.

4 While this wash is still wet, make a mix of Hooker's green, burnt sienna and French ultramarine, and add a dollop of this among the yellow ochre. Continue steps for the foliage further down the tree, and finish by putting in a few dabs and upstrokes of the green mix for the grass at the trunk base.

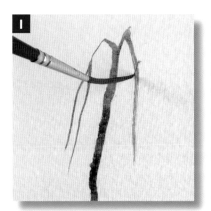

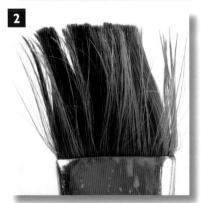

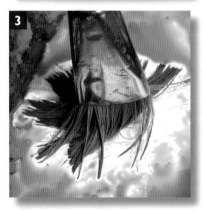

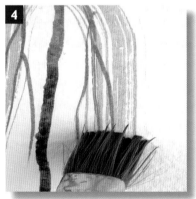

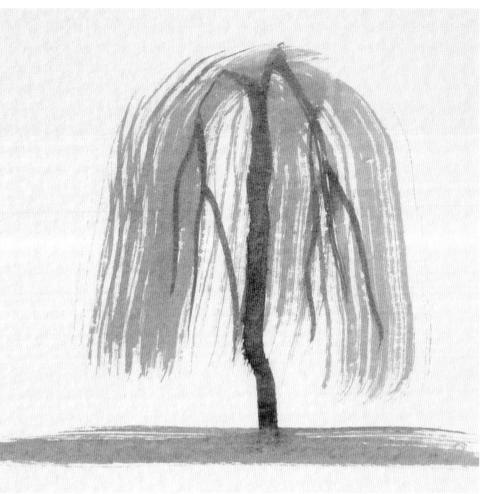

Weeping willows are lovely, atmospheric trees that really enhance a landscape. They have the reputation of being difficult to paint effectively, but here's how to achieve good results quickly.

1 Starting with a wash of raw umber, pull a No. 3 rigger brush up the paper for the main trunk, and then at the top turn the brush upside down and bring it back again for the 'weeping' branches. Repeat this routine, each time slightly thickening the trunk and adding another branch.

2 Good brushes are strong and will take any amount of abuse. So, once you've made a mix of Hooker's green and yellow ochre, split a ¾in wash brush by bashing its head into the palette.

3 Push the split bristles into the paint.

4 Starting from the top of the tree, drag the brush down in sweeping curves. Add a little ground at the base, and there is a weeping willow.

EXERCISE **WEEPING WILLOW**

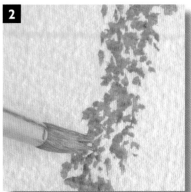

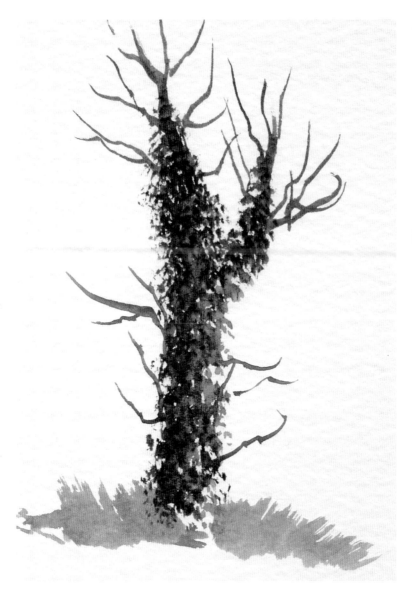

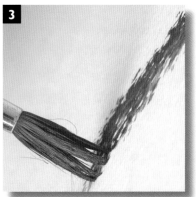

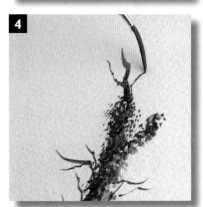

Overgrown and dead trees can be tricky, as you have to suggest the underlying shape of the trunk and branches without showing them. Try this method.

1 As for the willow on the previous pages, start by splitting a No. 8 round brush and then take yellow ochre from the palette.

2 Stipple on the colour in the rough shape of the trunk and main branches, making sure to leave white highlights of paper showing through.

3 Now make up a mix of Hooker's green and burnt sienna, and repeat the stippling, leaving some of the first colour to show the lighter side. Mix French ultramarine and burnt sienna, and repeat to darken further.

4 For the twigs, use a No. 3 rigger brush, and make a mix of raw umber and burnt sienna for the branches at the top. A final splash of green anchors the tree to the ground.

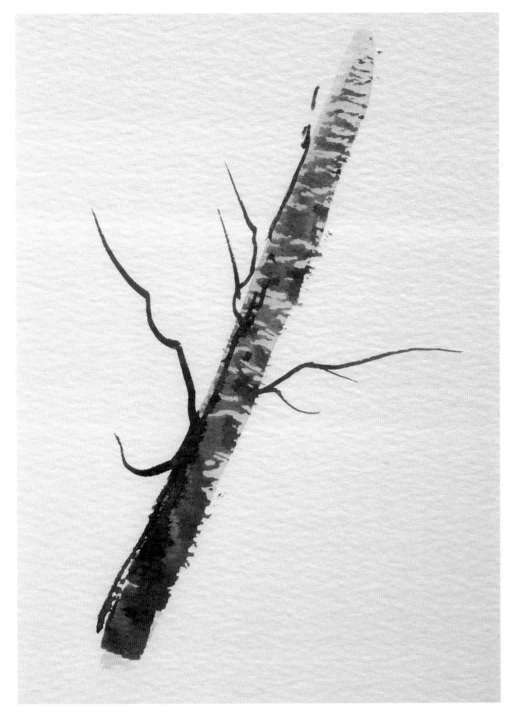

This particular species has a reputation of being notoriously difficult to paint. It's not the shape of the foliage that's tricky – it's the ridges and knobbly bits on the central trunk. But fear not; it can be done.

1 Using a No. 8 round brush, paint the trunk with a mix of yellow ochre and raw umber and let it dry; but you can use any colour you like, as it's just so as not to have white paper.
2 For the important strokes, make a mix of French ultramarine and burnt sienna, and applied it thus: hold the brush upright – not like a pencil – with the full length of the hairs resting on the paper, and drag it across the first wash, starting at the bottom and working up with less paint.
3 To finish add a few branches with a slightly darker version of the second mix.

EXERCISE SILVER BIRCH

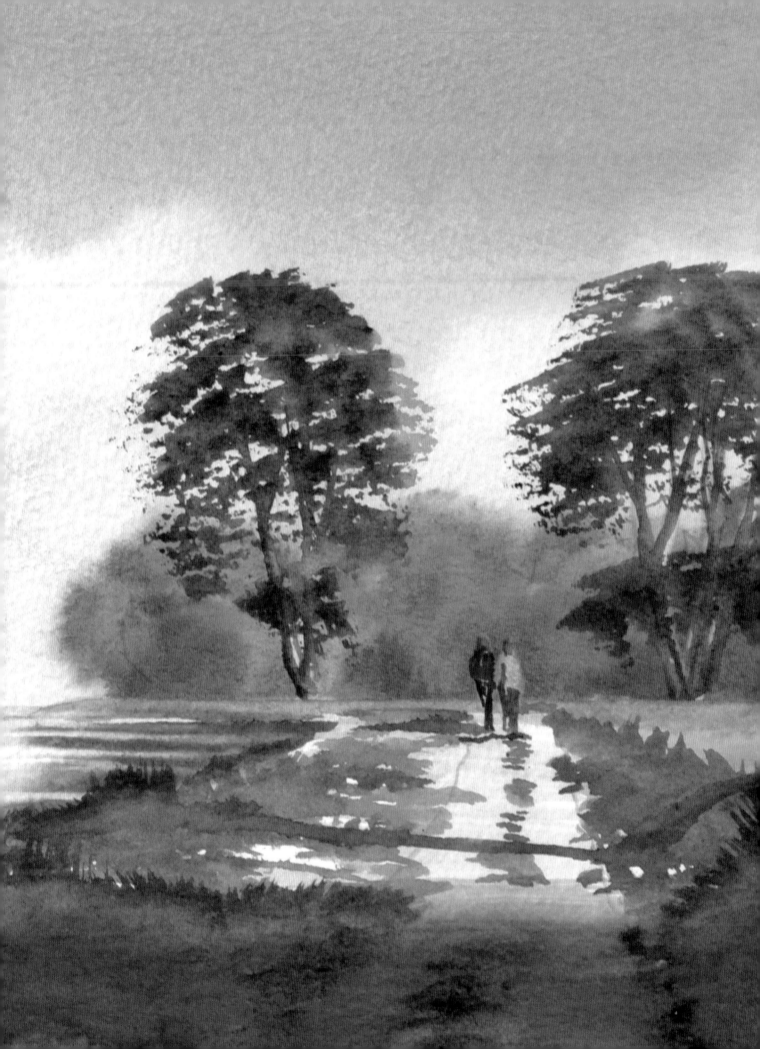

Landscape
With People

*The still trees and calm water give a tranquil feel
to this view. But there's a storm brewing, just look
at that cloud shadow in the foreground.*

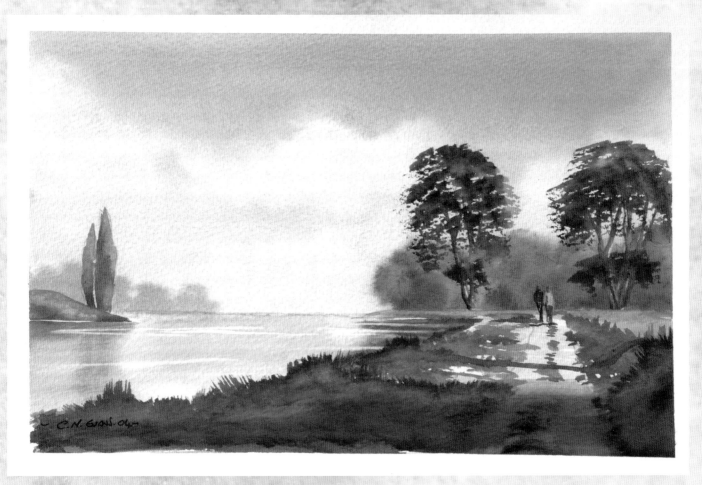

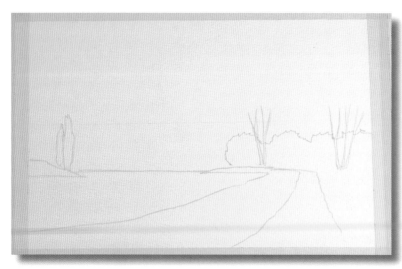

After masking the picture area, I make a simple outline drawing: first a squiggly line for the middle-distance trees, then a bank coming down on one side, out of the picture area. Next, the path comes in from the middle distance – here, the key thing is to make sure it is wider in the foreground. I add a few sticks to indicate the most prominent trees, followed by the water line and the bank on the far side of the river, and then I complete the drawing with a couple of poplars on the left-hand bank.

1 I wet the whole sky area with lots of water, then use a mix of alizarin crimson and yellow ochre, again watery, in the bottom third of the sky, all applied with a 1½in wash brush.

2 Using plenty of colour and a 1½in wash brush, I paint a mix of French ultramarine and light red right through the other washes down to the bottom of the sky area.
3 I finish this part by using an almost dry brush to mop up the bottom line, and then squeeze out the brush and suck out the clouds.
4 To get a hazy, distant feel to the trees in the middle distance, I use the ¾in wash brush to dab yellow ochre, followed quickly by a mix of Hooker's green and burnt sienna, using the side of the brush.
5 I make a nasty purple with French ultramarine and alizarin crimson, then knock this 'chameleon' colour back with burnt sienna, and paint over the trees.
6 I mop up along the bottom of the trees to make a sharp line.

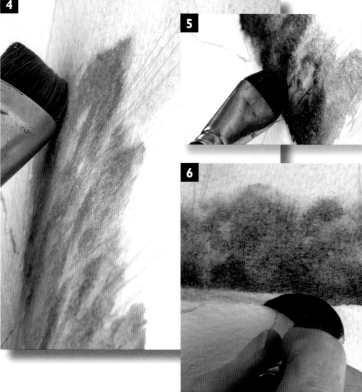

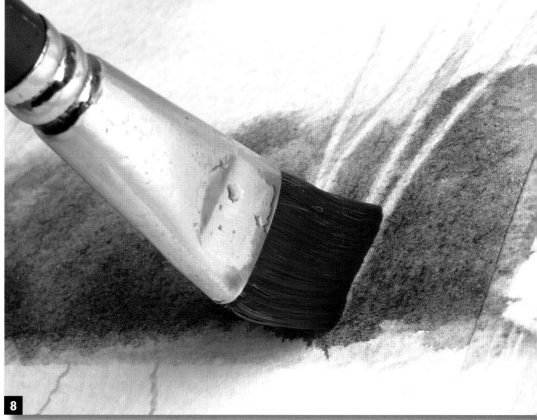

7 With the tree washes in place and still wet, I squeeze the ¾in wash brush firmly between my fingers to dry it out.

8 One of the myths of water-colour is that once you've made a mark you can't undo or change it. Rather than painting around the closer tree shapes, I simply use the dried wash brush to suck out the wet paint where the trees need to go.

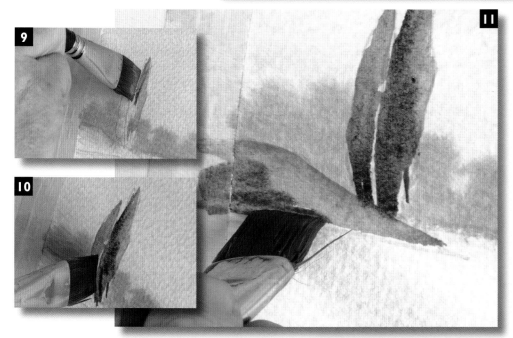

9 For the poplars on the left, I put a daub of yellow ochre on each tree, and follow this up by splashing on a mix of Hooker's green and yellow ochre.

10 I then add a touch of my shadow mix – French ultramarine and alizarin crimson – to the left-hand side of each poplar to finish these trees.

11 Next I repeat the same mixes in the same order for the bank between the poplars and the water; and that side of the picture is now complete.

12 Going back to the trees on the right side, I paint them in with yellow ochre using my No. 3 rigger brush, as I showed you in the tips and techniques on pages 46–51.

13 Using the same brush, I add raw umber to the left of the yellow ochre.

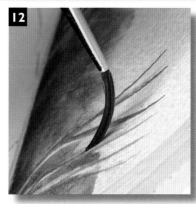

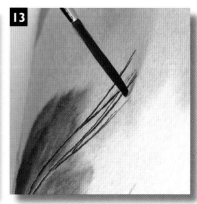

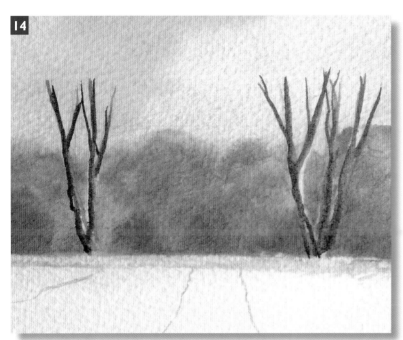

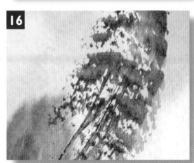

14 I next use the rigger brush to add the mix of French ultramarine and burnt sienna to the left of the raw umber, and then let the colours dry.

15 With the top edge of the ¾ in wash brush, I start the foliage with dabs of yellow ochre.

16 While this first wash is still wet, I dab on a mixture of Hooker's green and burnt sienna, and then add the shadow mix among the foliage.

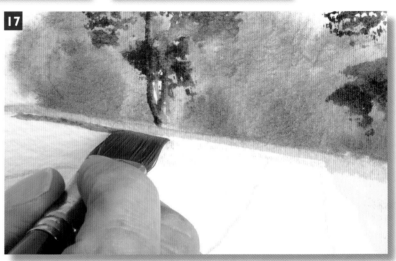

17 I load yellow ochre on to the same brush and use this to make the bank in front of the right-hand trees, and then add a mix of Hooker's green and burnt sienna below that to make it look as if the trees are standing on something. The next stage is to let all this dry.

That's the top half of the picture complete. Now I'm going to treat the water very much like the sky wash, and I expect to finish it in a few minutes, while the paper is sopping wet. I'm not intending to attempt perfect reflections, but to echo and capture the colours of the land features in the water. Usually, it's a good idea to make the reflection darker than the object itself.

18 First, I put lots of water into the water area, then drop a nice dark mix of Hooker's green and burnt sienna under the trees in the middle distance, using the ¾ in wash brush, then put some of this mix under the poplars on the right.

19 I then drop a touch of French ultramarine into some of the green reflected areas.

20 A touch of green mix goes nicely under the poplars.

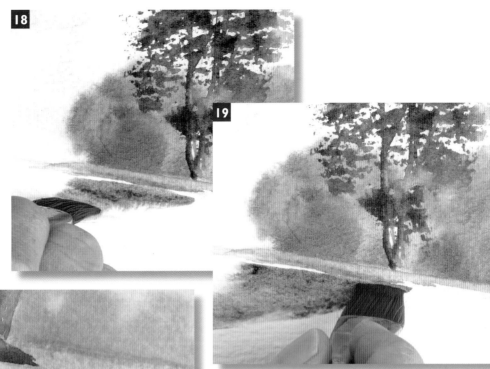

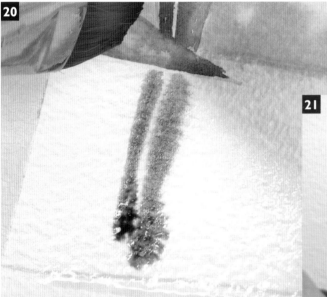

21 A touch of yellow ochre sits next to the green mix to show the reflection of the lighter side of the poplars.

22 Using a mix of French ultramarine with a tiny amount of light red, I fill in the middle parts of the water. Although I am moving the paint around on the wet paper, I make sure to go in one direction only – going in with the pigment and dragging out the ready-painted reflections only muddies the colours.

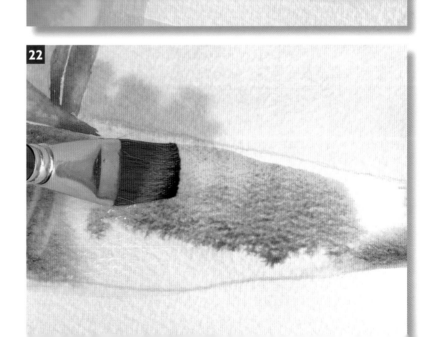

23 I mix the colours in the water by stroking the blue mix over the reflections.

24 Before the washes dry, I rinse, squeeze and shape the bristles of the brush and use it to draw out the pigment along to the right of the water area. Again, this effect can be spoilt if it's overdone, so I aim for just a few horizontal lines of highlighted white paper.

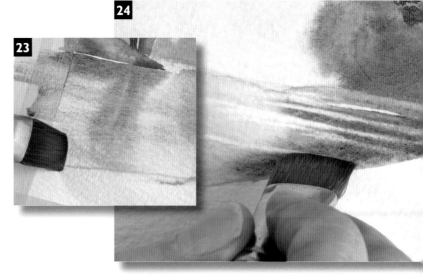

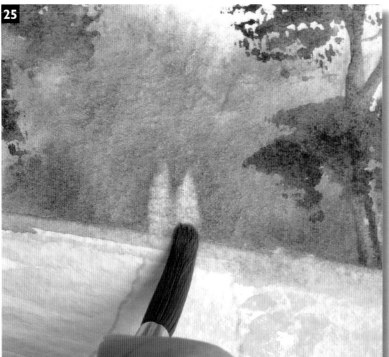

25 Having decided I want to add a couple of people to the picture, even though the right-hand trees are dry, I use clean water to dabble a wet round brush to suck out the paint and reveal lighter areas where I will place the people.

26 I put washes of yellow ochre on the path, lighter in the distance and a little stronger in the foreground, and then use the tip of the wash brush to show the rounded contours of the ground on the left, using a little raw umber mixed into the yellow ochre.

27 Sticking to the ¾in wash brush, I repeat this for the ground to the right of the path.

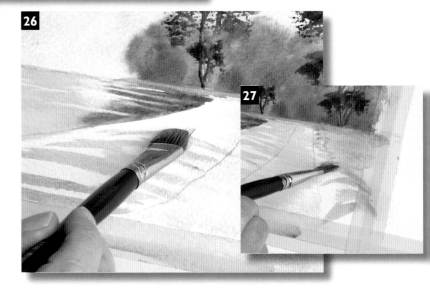

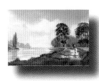

LANDSCAPE WITH PEOPLE

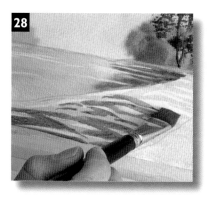

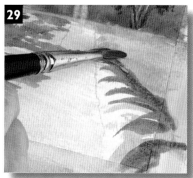

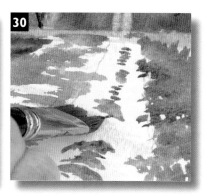

28 For the grass by the water's edge I use the wash brush to slap on a mix of Hooker's green, yellow ochre and a touch of French ultramarine, plus plenty of water; I'm not after much detail.

29 I break up the edge of the path with a few flicks of the green mix, using the ¾in wash brush for the ground contours; again, I avoid putting in too much detail.

30 To add patches of grass to the centre of the path, I rock the wash brush backwards and forwards, creating a rough effect.

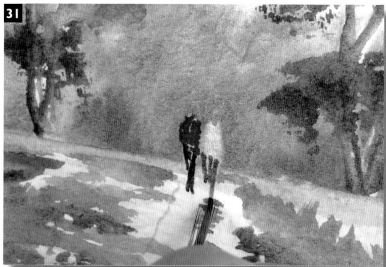

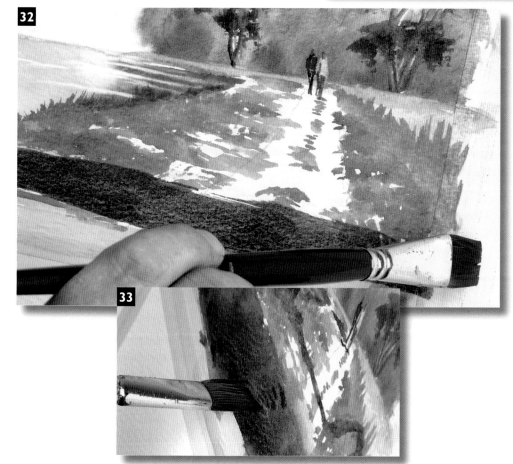

31 While the green dries, I go back to the people with the rigger brush. I place a couple of blobs of a mix of yellow ochre and alizarin crimson for the heads, add some alizarin crimson for one top, then a mixture of French ultramarine and burnt sienna for the legs – and the blobs become people.

32 Now I do something really scary: I mix French ultramarine and alizarin crimson, knocking it back with a bit of burnt sienna and plenty of water, and then pull big strokes of this over the whole foreground area with the wash brush.

33 I finish by inventing shadows for the people, plus one for a thin tree, and then add some dark tones within the dark areas to establish the edge of the path. That's it; all done.

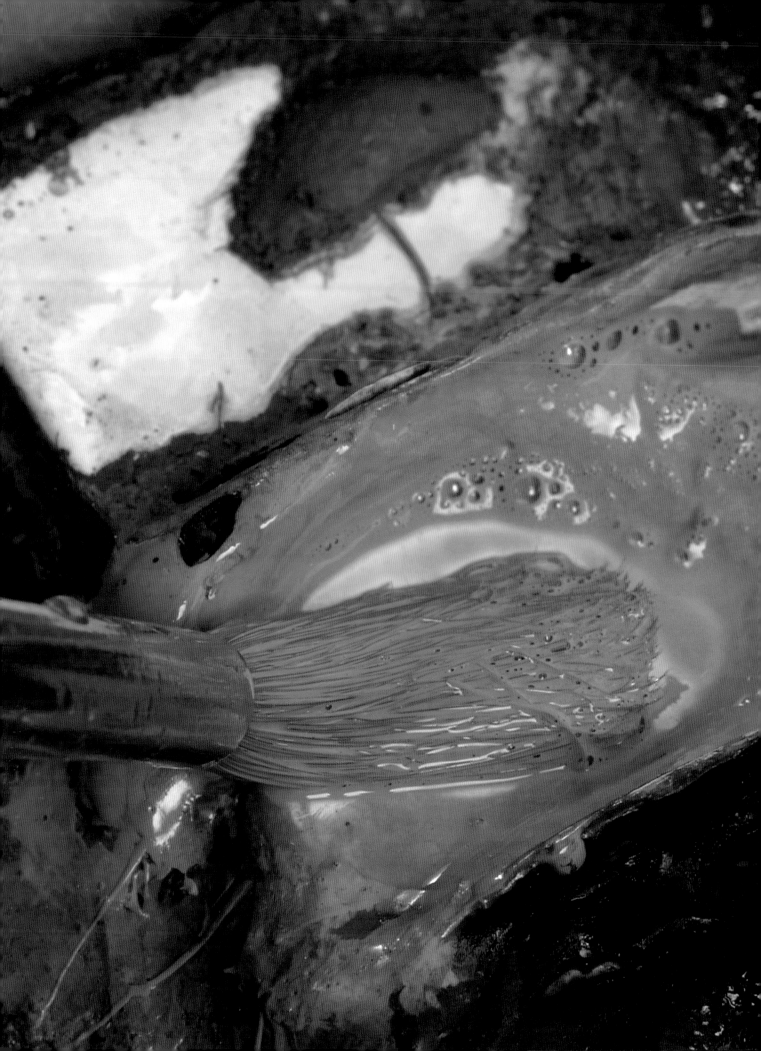

EXERCISE
PEOPLE AND ANIMALS

Don't worry – 'people' here doesn't mean life drawing! Keep people and animals small and in the middle distance, and make your people walk away from you, and you should be fine.

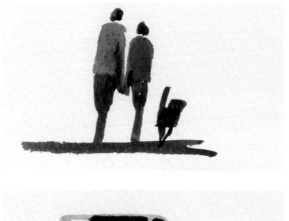

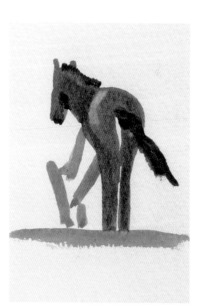

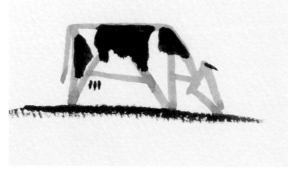

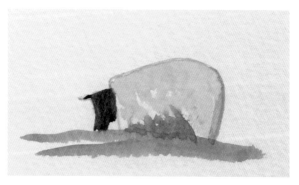

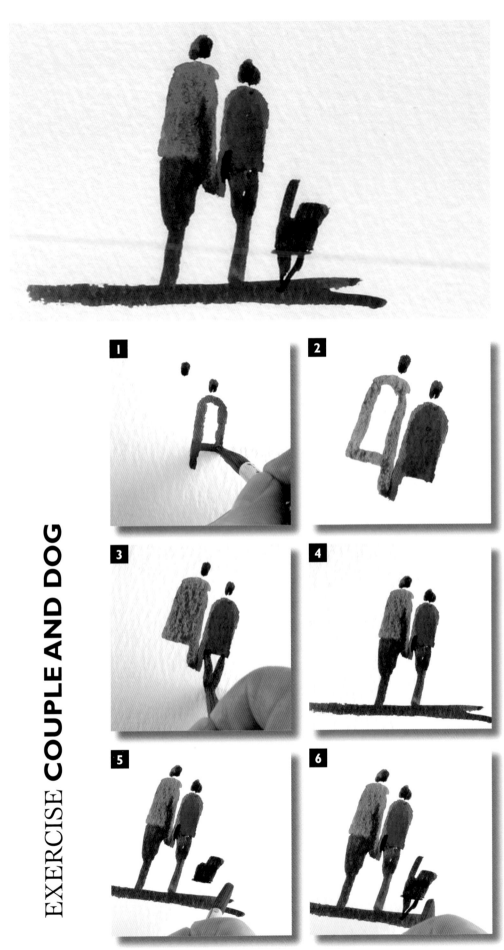

There are lots of methods used to paint people, but I reckon that if you can paint a 'Y' and a 'P', you shouldn't have any problems with painting people. As a free gift, here's a dog as well.

1 Using a small round brush and any colour you like, put two full stops on the paper. Leave a little gap below the stop on the right, switch colours and add 'P'.

2 After filling in the empty part of the 'P', change colours again and paint a reversed 'P' under the left-hand stop, once more leaving a tiny gap.

3 Fill in the second body and then change colours and draw the letter 'Y' under the first figure, this time joining it up to the bottom of the body.

4 When filling this in, leave a tiny bit of white paper to suggest the gap between the thighs. Paint the next 'Y' and fill it in, before making a few strokes to show the ground.

5 For the dog paint a square and a smaller square on top on the right.

6 Then add two sticks joined on to the larger square below and one above, and there you are – done!

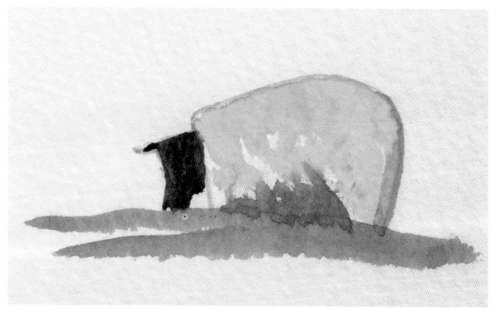

For sheep, you don't need to see four legs, two ears and a wagging tail – all you need is a loaf of bread with a lump on the end! Here's what I mean.

1 Start by drawing the loaf and the lump at one end, with a bit sticking out of the lump for an ear. Note that you don't even need to draw the lines right down to the ground.

2 Using a No. 8 round brush, put a few dabs of yellow ochre along the top of the loaf, going up to the drawn edge. Then put a mix of French ultramarine and burnt sienna at the right end of the loaf and a line to make an incomplete 'V' below.

3 Using the same mix, colour in part of the bottom of the loaf.

4 Now add a few dabs of the second mix to the yellow at the top and switch to a dry brush to mix the two washes together.

5 After mixing the French ultramarine and burnt sienna to a black, colour in the lump at the end of the loaf. A few strokes of green for grass, and there's the sheep grazing away contentedly.

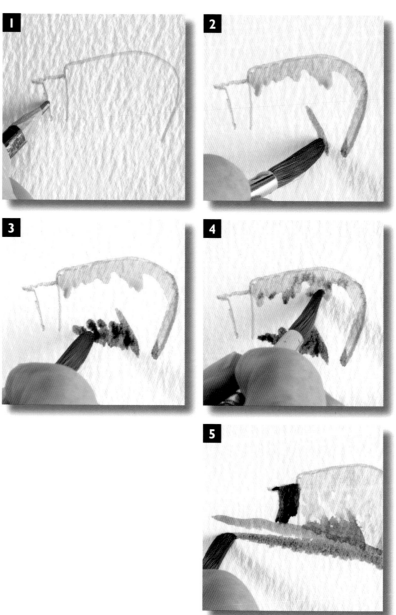

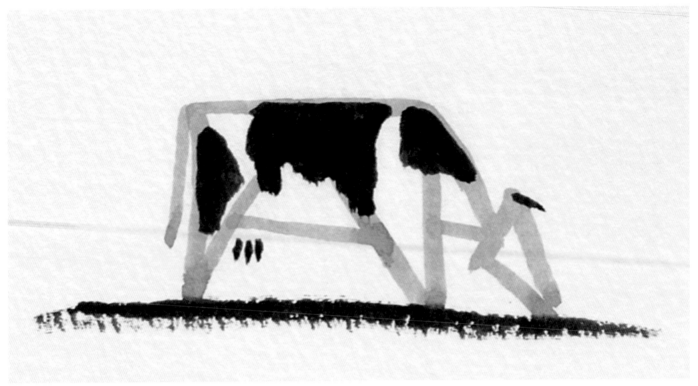

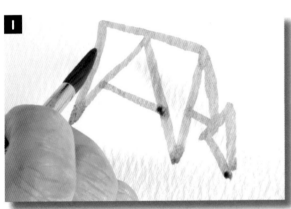

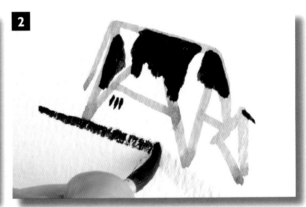

EXERCISE COW

As with all the animals here, you need to make them small and put them in the middle distance or even further away – we're not talking about the cover of a farming magazine!

1 Start by mixing a light wash of French ultramarine and burnt sienna to make a grey, and then use a No. 8 round brush to paint a series of triangles as shown. Don't forget the tail, which hangs off the back triangle.

2 With a black mix of the same colours, colour in parts of the triangles in cow markings. Then it's just a matter of sticking an ear on and some dangly bits underneath, a line to represent the ground, and there's your cow.

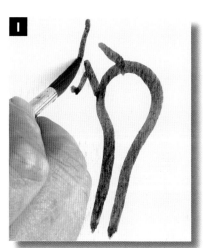

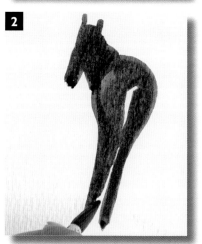

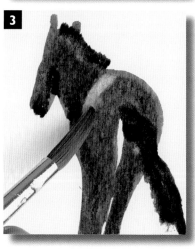

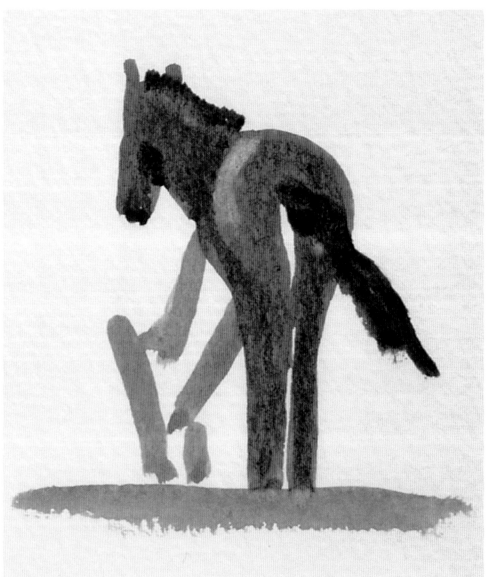

Traditionally, horses are among the most difficult things to paint, because they are complex. But if your horse is in the middle distance, all you need is a light bulb.

I Making up your horse colour from raw umber, paint a thin light bulb and add two sticks off the top and a block at the end of them to make the head.
2 With the same mix colour the horse, leaving a little white paper as a highlight.

3 Then use a darker version of the mix for the mane, tail and shadows, then rinse and squeeze out the brush to take off paint for contours. If you want the horse to be grazing, simply angle the sticks and head of step 1 downwards (as shown above).

EXERCISE **HORSE**

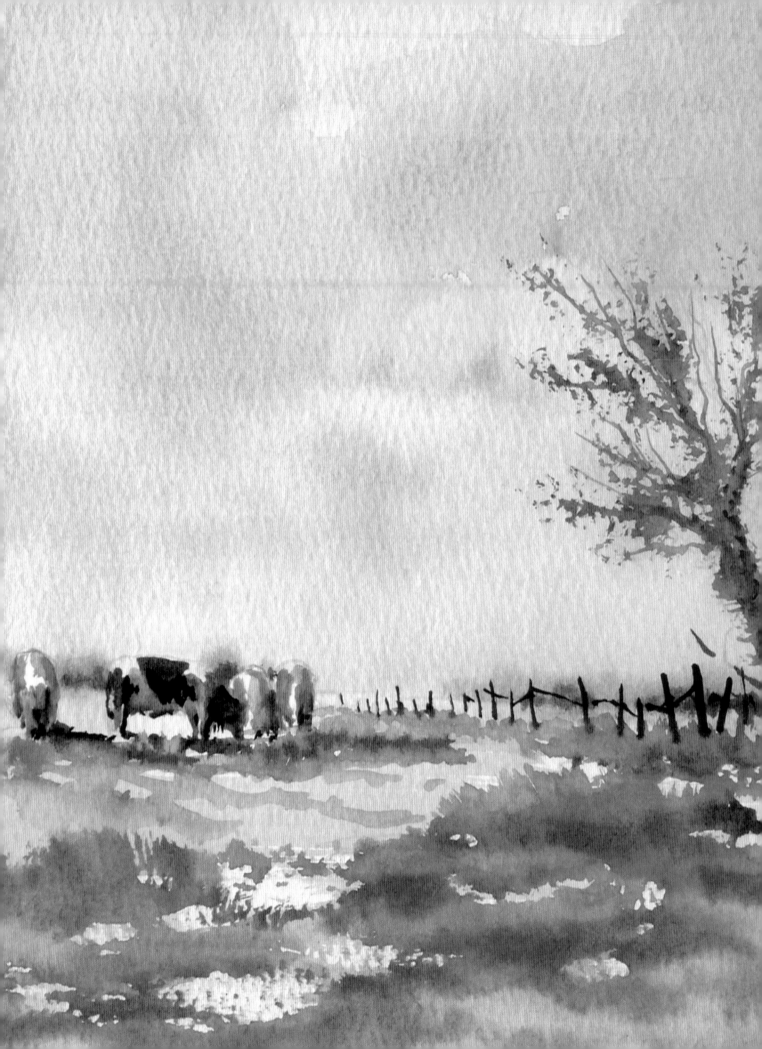

Cows and Sheep

A pastoral scene with grazing animals is always

attractive – and cows and sheep usually stay still

long enough for you to paint them!

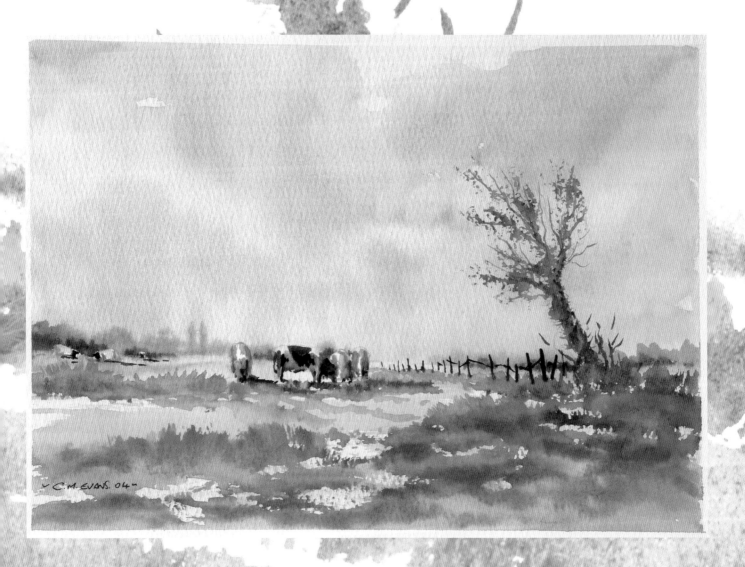

Compared to the finished painting shown on the previous pages, the initial drawing here may look a bit bare and lacking in detail – but that's all part of the plan. If you aren't completely bound by pencil lines, you have more freedom to use techniques such as blending and softening, drawing out paint and so on.

1 After masking the edges of the paper, I make the inital drawing as a guide to get me started. I then apply a very well watered-down wash of yellow ochre, using a ¾ in wash brush, over everything...

2 ...with the exception of the shapes of the cows and sheep. I'm not using masking fluid for this because there is nothing else happening, so it is easy.

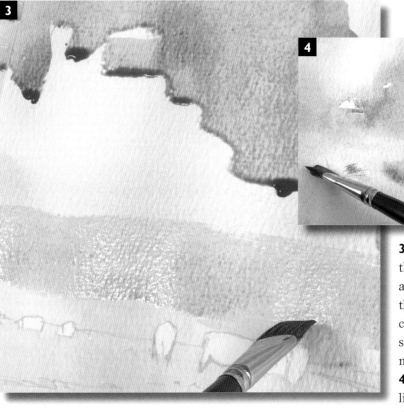

COWS AND SHEEP

3 I allow the first wash to dry, then use a mix of cobalt blue and plenty of water to block in the sky, this time leaving the cloud areas unpainted. I also soften the bits where the blue meets the unpainted areas.

4 With a mix of cobalt blue and light red I drop in a few cloud shadows using the side of the brush, and allow all this to dry for a while.

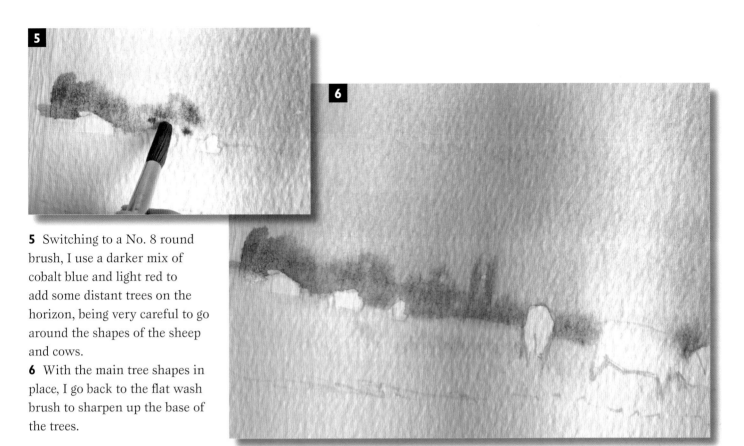

5 Switching to a No. 8 round brush, I use a darker mix of cobalt blue and light red to add some distant trees on the horizon, being very careful to go around the shapes of the sheep and cows.

6 With the main tree shapes in place, I go back to the flat wash brush to sharpen up the base of the trees.

7 I now use the flat brush to drop in a light wash of light red across the ground in the middle distance, allowing the original wash of yellow ochre below to show through.

8 While this wash is drying, I switch back to the No. 8 round brush and use a quite dark mix of cobalt blue and light red for the darkest trees on the far left of the picture. Here, my aim is to have a dark enough area to accentuate the white patches that are the sheep.

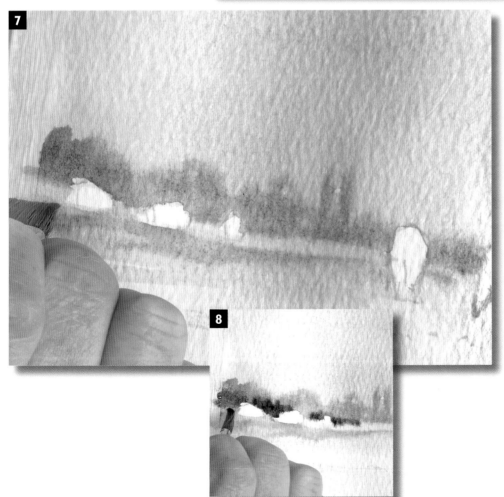

9 I make up a black with a mix of French ultramarine and burnt sienna, and drop this as a first touch of colour on what will become the main cow in the picture. While this is drying, I make up a mix of raw umber and light red, and use this to add colour and shape to the cows on either side.

10 After mixing Hooker's green and burnt sienna with plenty of water to make a nice watery green, I switch to a No. 3 rigger brush for the leaves on the right-hand foreground tree. I use the brush on its side to create bunches of leaves, and make sure not to carry surplus water on the brush, which could run and make too large a mark.

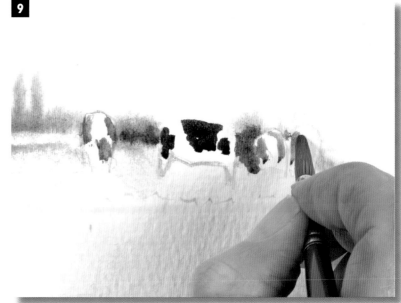

Top Tip

KEEP LOOKING OVER THE WHOLE PICTURE REGULARLY – STANDING BACK HELPS. EVEN WHEN YOU'VE DECIDED TO WORK QUICKLY, TAKING FREQUENT OVERVIEWS CAN BE INVALUABLE.

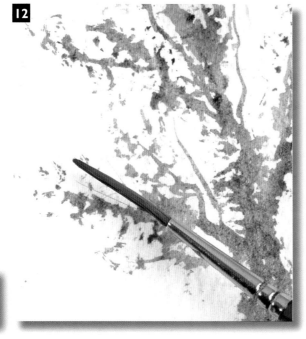

11 With a mix of cobalt blue and light red I use the tip of the rigger brush to make branches that link the green splodges of leaves.

12 I wash and almost completely dry the brush, and then use it to add tiny touches of shadow colour created with a mix of burnt sienna and French ultramarine – nowhere near as strong or dark as the mix I made with the same colours for step 9.

COWS AND SHEEP

13 However, I do use the black mix of burnt sienna and French ultramarine for small blobs that I shape to make the heads of the distant sheep.

14 Still using the rigger brush, I add a touch of yellow ochre on to their backs. I let this dry a bit and then put a tiny touch of a light mix of French ultramarine and burnt sienna for the shadows.

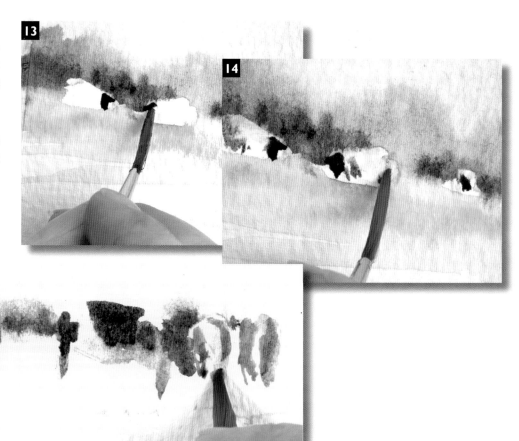

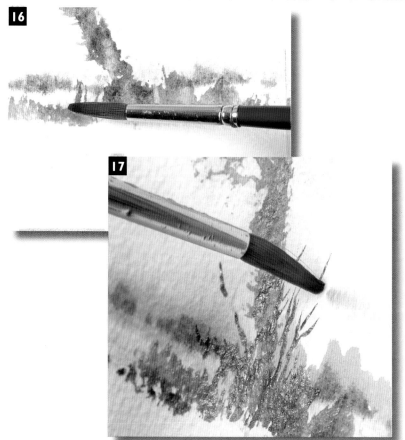

15 With the same shadow mix, but after watering it down to make a very weak mix, I go back to the cows; to capture light on the top and on parts of the sides, I leave some areas unpainted.

16 I make a mix of light red and burnt sienna and use the No. 8 round brush to add a few marks and flicks on either side of the main right-hand tree.

17 Sticking with the same brush, I make up a sepia from burnt umber and French ultramarine and make a few more flicks upwards underneath the tree. I use the same combination to create small branches and twigs at the side of the trunk.

18 For the foreground I go back to the flat brush to lightly stroke a watery mix of yellow ochre and raw umber over the area, leaving sparkles of white paper showing through.

19 I now mix Hooker's green and light red, and put just a bit of pigment on the tip, dabbing this colour on to create the idea of rough grass.

20 Here and there I flick the brush upwards to join the colour to the dark undergrowth at the base of the tree.

21 I take the same colour over to the middle of the picture and paint a band of grass around and to the right of the group of cows.

22 Using my 'shadow mixture' of French ultramarine, alizarin crimson and burnt sienna, I add some shadow detail underneath the cows with the No. 8 round brush.

23 I use the same mix and brush to add just a few shadows to the foreground grasses...

24 ...and some more touches to the sides of the path; these also help to create contours and show the bumpy nature of the ground.

COWS AND SHEEP

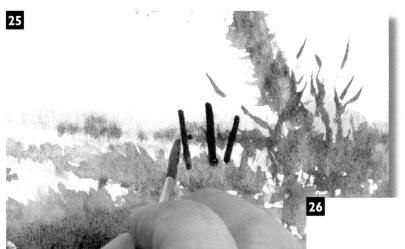

25 I think this picture needs a few verticals in it, to add a sense of depth and recession, and to help make the whole thing feel more complete. So I make up a mix of raw umber, burnt sienna and French ultramarine, and use the rigger brush to add some old wooden fence posts.

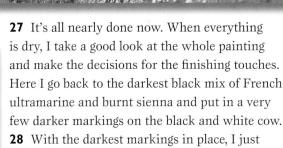

26 Any kind of vertical is a great aid to creating depth and distance. I make sure that the posts get smaller as they go away from the foreground, and join them up with irregular horizontal strokes – a brand-new, uniform fence would distract the eye from the main focal points and make the painting look regimented.

27 It's all nearly done now. When everything is dry, I take a good look at the whole painting and make the decisions for the finishing touches. Here I go back to the darkest black mix of French ultramarine and burnt sienna and put in a very few darker markings on the black and white cow.

28 With the darkest markings in place, I just reinforce some of the shadows beneath the cows – and that's it!

EXERCISE
TREES IN WATERCOLOUR PENCIL

The next project (see page 81) uses watercolour pencils as a variation on paints; try out the trees in these exercises to give you a feel for using these versatile tools.

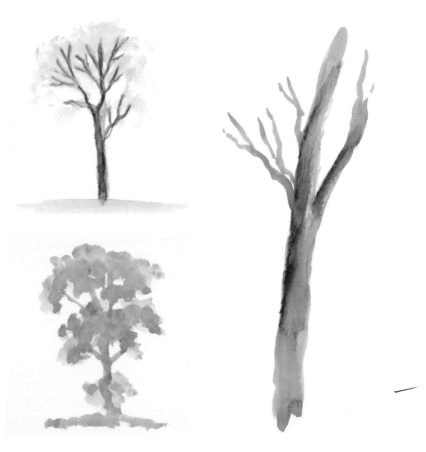

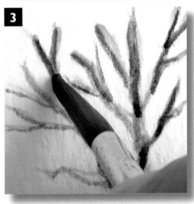

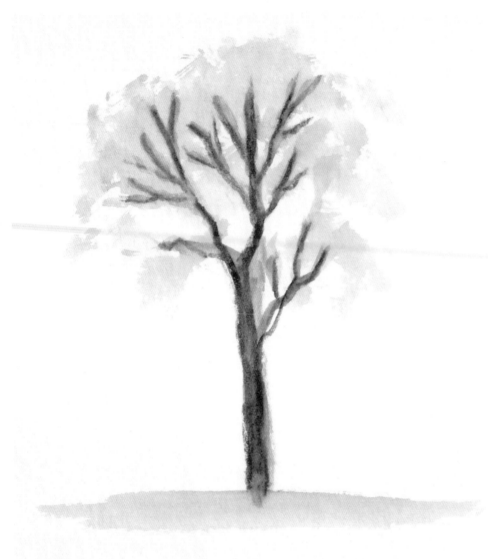

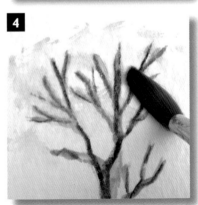

EXERCISE WINTER TREE

When painting bare winter trees, I always exaggerate their darkness to make the overall result more effective, especially on a lone tree as shown here.

1 Draw the basic shape of the trunk and main branches with a black watercolour pencil; don't try to make the colour too dark when drawing.

2 Next put yellow ochre pencil on one side of the tree and along most of the branches. Don't try to follow the exact line of the black, but give the impression of a canopy of twigs.

3 Taking clean water on a No. 8 round brush, go over the whole tree. This darkens the colours and gives a varied texture – you don't want to smoothe everything out.

4 Rinsing the brush, take up just a little heavily watered black pencil to show the winter growth and ground – and there you have it!

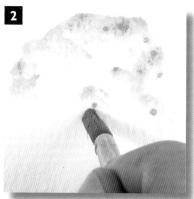

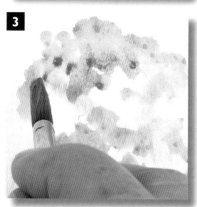

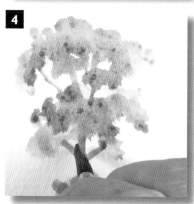

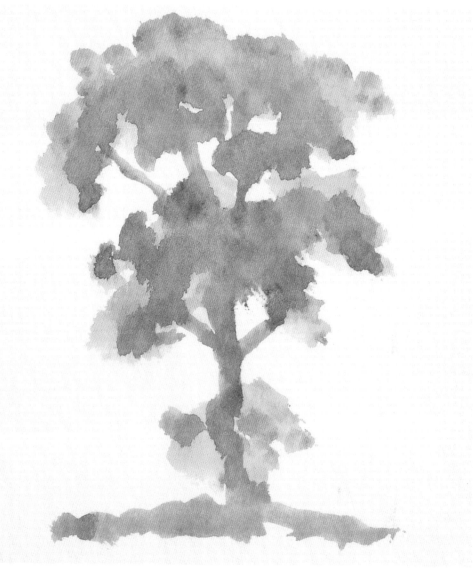

For a tree in full foliage, try mixing all the colours on the brush – just as you'd do for watercolour paints, only taking the pigment from the point of the pencil.

1 First dip a No. 8 round brush in clean water, make a mixture of dark green and brown ochre from the watercolour pencils.
2 Then dab the brush on the paper to make masses of leaves – keep everything light at this stage, and don't worry about little dots of accumulated pigment here and there.

3 While the paint is still wet, quickly add some blue-grey to the mix on the brush and again dab this on for the darker parts of the foliage, still leaving white paper for birds to fly through.
4 To finish, clean the brush, take straight blue-grey on to it from the pencil, and drag the pigment for the branches, trunk and ground at the base.

EXERCISE TREE IN LEAF

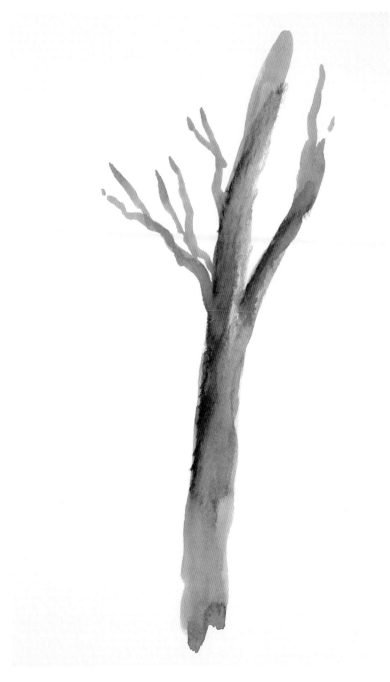

1 The first pencil colour is brown ochre, which you can use for the lightest tones on the tree.

2 Follow this on one side with brown pencil – don't try to cover all the paper with the pencil marks, as the water will do that later.

3 Next add some black pencil for the darkest, shadowed side.

4 At the moment everything looks like a vertically striped, odd-coloured stick of rock with a growth on the side...

5 ... but dip a No. 8 round brush in clean water and stroke the tip on to the pencil marks...

6 ... blending the colours as you go. It's important to just make the strokes along the length of the trunk – if you mess about too much and go back over what you've done with the brush, the effect will be muddy.

7 Drag some of the merged colour from the trunk to make a few branches and twigs.

8 After rinsing the brush go gently along the main branch, again being careful not to overblend or merge the colours.

9 Let everything dry, and hey presto! you have a lovely rounded tree trunk with knots and all.

This exercise uses both dry watercolour pencil work and brushwork to give a strong final effect. The main things here are to work quickly when adding the water to the pigment marks and not to spend time looking for a polished result – the roughness makes the character of this tree.

EXERCISE **BLENDING TREES**

Water Scene

*This peaceful little scene is very quick and easy to
do: all you need is a box of watercolour pencils,
a brush, some water and a pen to finish off.*

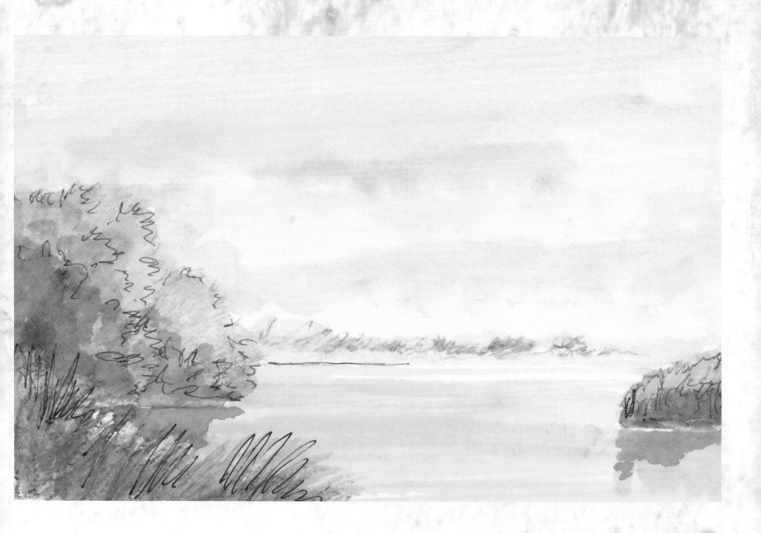

I have owned my tin of 24 Derwent watercolour pencils for over six years now, and I am still using all the original pencils – so this is a pretty economical way to work! (It also helps that I use a sharp knife for sharpening, not a pencil sharpener, which eats any pencil quickly.) As usual, for this project I start with gunmetal grey for the very simple outline; unlike a standard pencil, with watercolour pencil the lines disappear when water is applied, so all I am doing at this point is providing a few guiding lines.

1 Inside the tree outlines, I add a little bit of brown ochre, just colouring in like a child's drawing and capturing light here and there by leaving patches of white paper.
2 Now I continue this colouring in with dark green, going over the ochre in places.
3 With watercolour pencils, the harder they are pressed, the stronger the colour they provide, so I get a feeling of recession by lightening the pressure as I go.

WATER SCENE

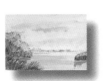

4 Moving on to the distant bank, I put in a tiny touch of purple, using nice light strokes above a very sparse line of brown ochre. I'm making no attempt to keep the lines straight, but looking for bumps.

5 Going back to the first area, I put blue-grey marks across the other colours.

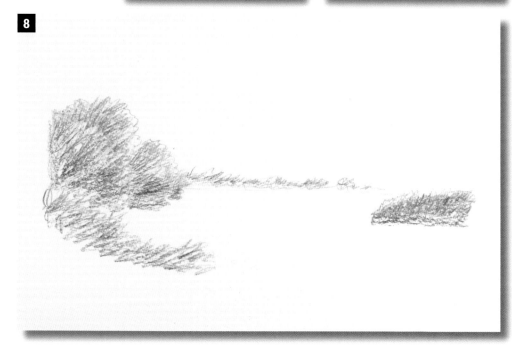

6 With watercolour paints, I use Hooker's green; with watercolour pencils, I put the colours on top of each other – first the blue...

7 ... and then the yellow. It may not be green yet, but just hang on.

8 Right – that's the main bit of drawing done. Now it's time for the magic!

9 For a large area of one colour, scratching and then wetting pencil lines doesn't give a very smooth result, so with a No. 8 round brush and clean water, I stroke Prussian blue off the pencil and start to make washes for the sky. Some people call this a graduated wash – I say whack it on!

10 Now I rinse the brush and stroke some blue-grey off the pencil to add clouds; and there's a quick and clever way to make a watercolour pencil sky.

11 For the rest of the painting where there are pencil marks, I simply go over the marks with a clean brush and merge the colours together.

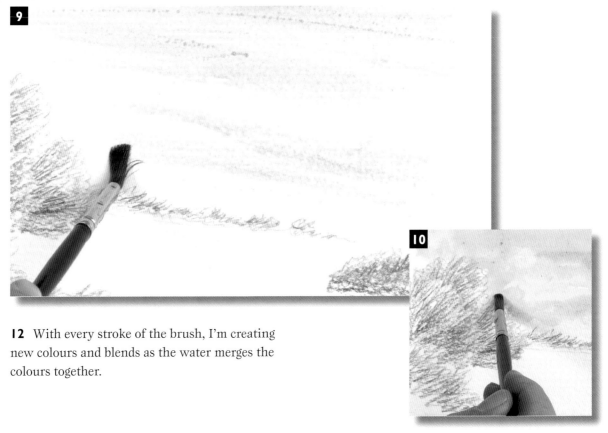

12 With every stroke of the brush, I'm creating new colours and blends as the water merges the colours together.

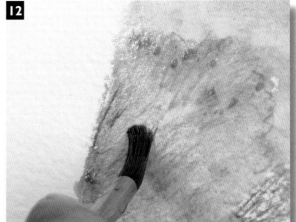

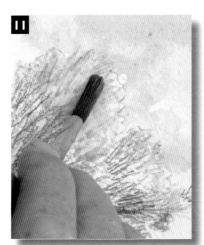

WATER SCENE

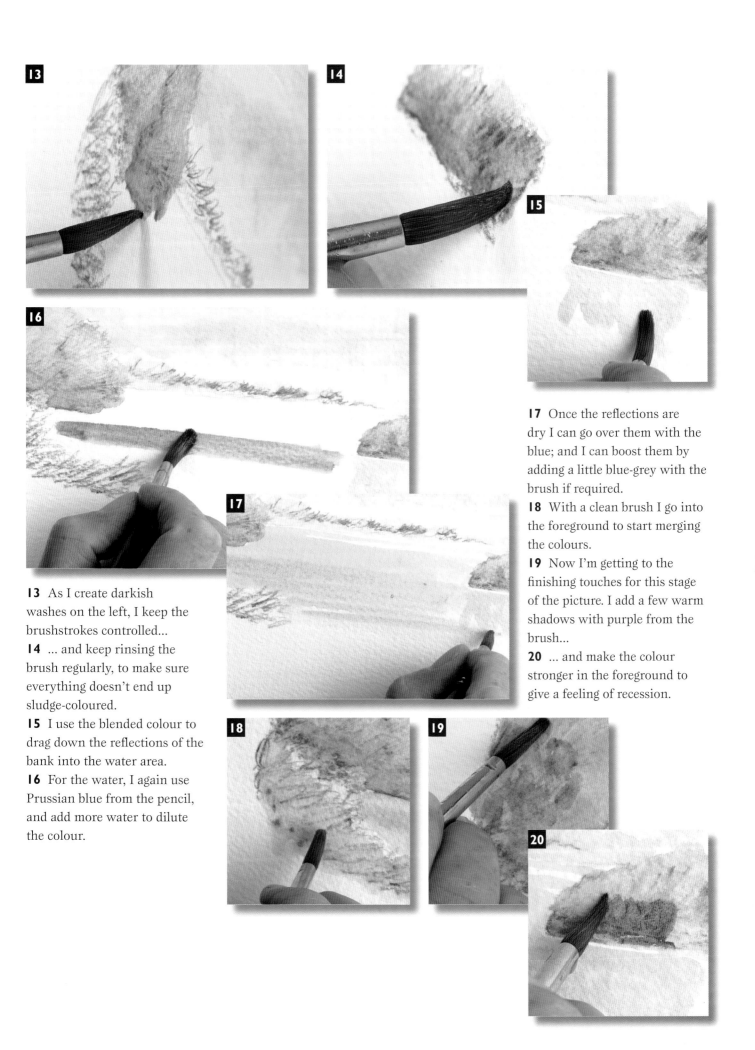

13 As I create darkish washes on the left, I keep the brushstrokes controlled...

14 ... and keep rinsing the brush regularly, to make sure everything doesn't end up sludge-coloured.

15 I use the blended colour to drag down the reflections of the bank into the water area.

16 For the water, I again use Prussian blue from the pencil, and add more water to dilute the colour.

17 Once the reflections are dry I can go over them with the blue; and I can boost them by adding a little blue-grey with the brush if required.

18 With a clean brush I go into the foreground to start merging the colours.

19 Now I'm getting to the finishing touches for this stage of the picture. I add a few warm shadows with purple from the brush...

20 ... and make the colour stronger in the foreground to give a feeling of recession.

21 I take a short break at this point, to let everything dry completely and to look at the overall picture. Working with the pencils again, I next add some squiggly lines for the foreground grass, using dark green.

22 I then repeat the strokes with blue-grey, both creating lines in new areas and going over some of the green ones.

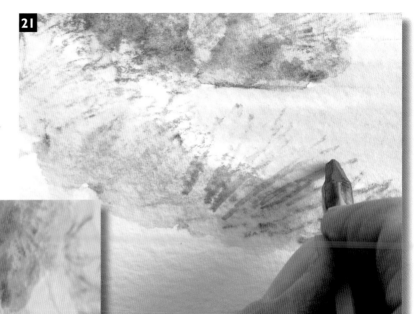

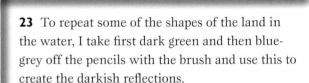

23 To repeat some of the shapes of the land in the water, I take first dark green and then blue-grey off the pencils with the brush and use this to create the darkish reflections.

24 I use the same colours on the other side of the picture, being careful to echo only the darkest shadows on the bank.

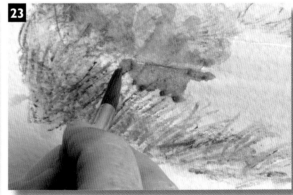

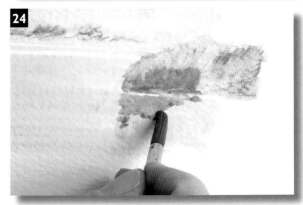

WATER SCENE

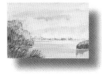

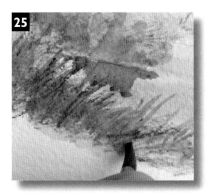

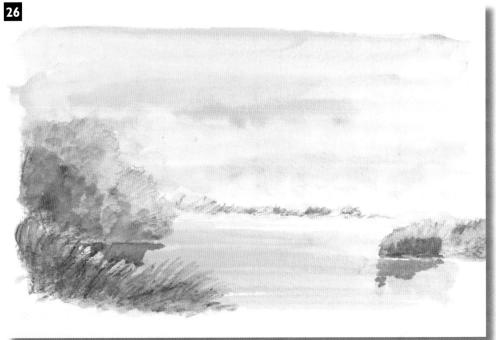

25 To match the reflections, I add a few more dark green grasses with the pencil.

26 And there we have a very simple watercolour pencil and wash painting – but I feel it needs a little more definition here and there.

27 When everything is completely dry, I use a thin-nibbed green gel pen to add just a few squiggly lines to pull out the areas I want to stand out.

28 What I'm *not* doing here is line-and-wash work – this is purely to add a tiny, but important, amount of emphasis.

29 Moving to the right-hand bank I add a few more lines, then switch to black pen for the foreground grasses – and that's the finished painting.

EXERCISE
BUILDINGS

Unless you're planning to paint town or city scenes, your landscapes aren't likely to feature too many buildings. The quick exercises here show you how to slap on paint for a good result.

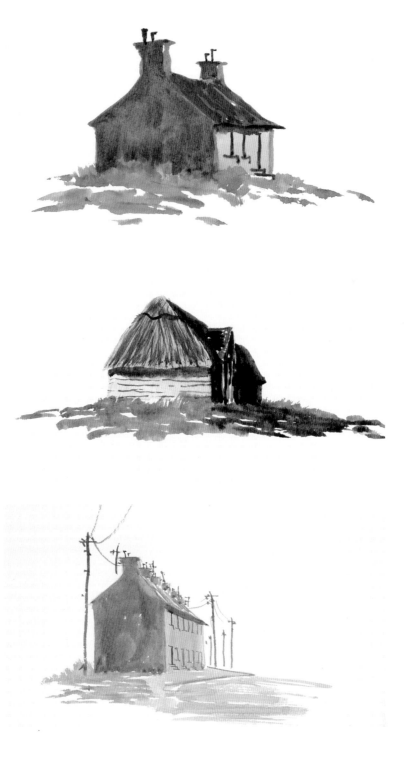

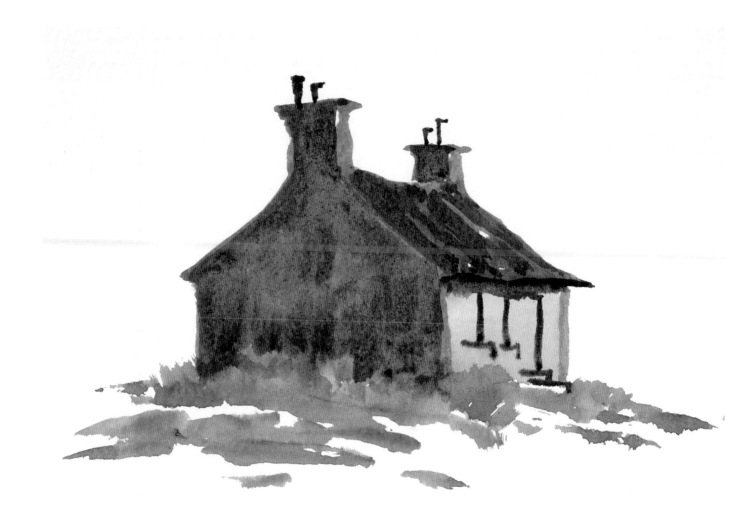

EXERCISE COTTAGE

A very simple building to make a start with is a single small cottage on moorland. The whole building can be done with just one brush.

1 Using a No. 8 round brush, paint the closest end of the building, far chimney and one sloping roof line in raw umber.

2 Make a light mix of French ultramarine blue and burnt sienna, and use this to make the two horizontal roof lines – and there's the building shape.

3 With a slightly darker blue mix, block in the roof, leaving a few white gaps.

4 While this is drying, fill in the nearest wall with a strong wash of raw umber.

5 The other visible wall is lighter than the near one, and for this use a very watery raw umber wash.

6 Now the roof is dry, make up a third, darker mix of French ultramarine and burnt sienna, and go over parts of the roof, following the slope.

7 When the light wall is dry, use a very dark mix of French ultramarine and burnt sienna and make a tick mark for the window, plus one for the ledge.

8 Finish all the windows and do the door in the same way, then use more ticks for the chimneys. A little Hooker's green and raw umber applied with a flat brush for the grass, and there's the cottage.

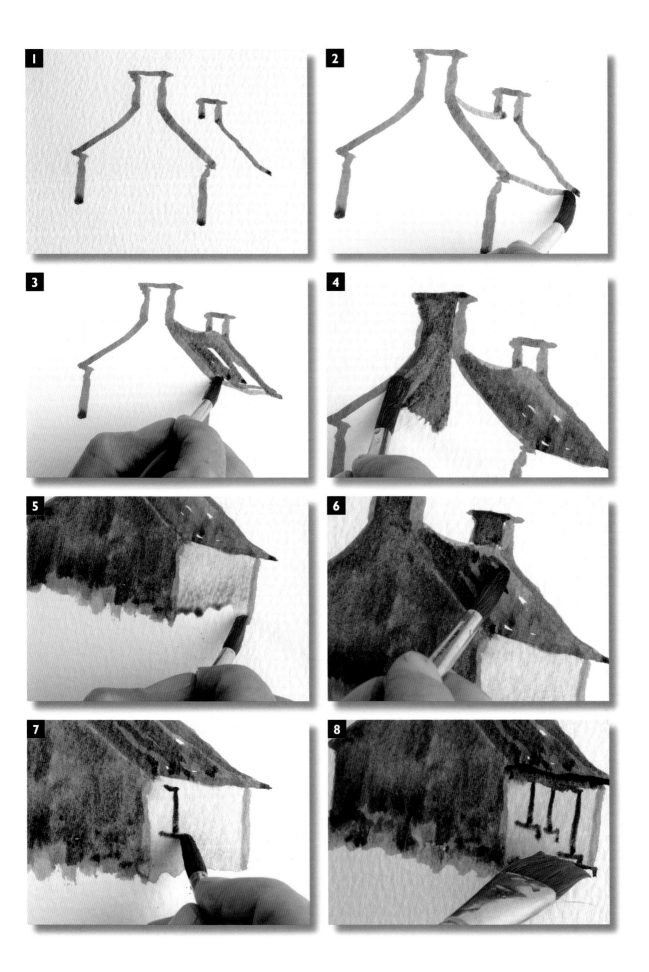

Thatched buildings don't have sharp edges and straight lines – the character is in the unevenness, and you only need to give an impression of the thatch itself.

1 Using a gunmetal grey watercolour pencil draw a simple outline – the 'point' of the roof is actually round.

2 Use a No. 8 round brush and yellow ochre to block in the near side of the thatch, then use burnt sienna to drop in the highlighted parts of the front. Then use a black mix of French ultramarine and burnt sienna to paint the shadowed front roof.

3 With the same mix fill in the shadowed parts of the front, including the windows.

4 Now smash the brush into a watered-down mix of raw umber, splitting the hairs, and stroke it on to the dry ochre, and follow it with a watery mix of the black.

5 For the side of the barn, add more French ultramarine to the black mix with a lot of water.

6 Use the full-strength mix and a No. 3 rigger brush to paint the thatch tie across the roof, which shouldn't be a straight line.

7 For a few lines to suggest the planks at the side, use the same mix and brush.

8 To finish, go back to the round brush and a light black mix for the roof shadow. A last bit of green with the shadow of the barn, and that's it done.

EXERCISE THATCHED BARN

For a row or terrace of houses, the rules are the same as for the single cottage on pages 90–91, but you have to make sure the chimneys, windows and doors match up.

1 Start by drawing the end of the nearest house with a gunmetal grey pencil.

2 After extending the bottom of the roof line and adding the far wall end, draw in the chimneys, making each one smaller as it goes away. Then block in the end wall with raw umber and a No. 8 round brush.

3 Next touch in the near side of the chimney sides with the same mix.

4 Use a watered-down version of the umber for the front of the buildings, then use a light mix of Frnech ultramarine and burnt sienna for the roof slope, leaving white gaps.

5 Switching to a No. 3 rigger brush, use a black mix of French ultramarine and burnt sienna for the chimney pots, painting them with ticks.

6 As for the single cottage, use ticks to paint in the windows.

7 Then add more windows and doors, this time adding steps to the doors with a further series of ticks.

8 For the final touches, put in the television aerials and telegraph poles and wires with a light version of the roof blue, and use the same mix for the roof shadow. A bit of grass by the side, and some watered umber and blue mix in front of the houses, and you're there.

EXERCISE **ROW OF HOUSES**

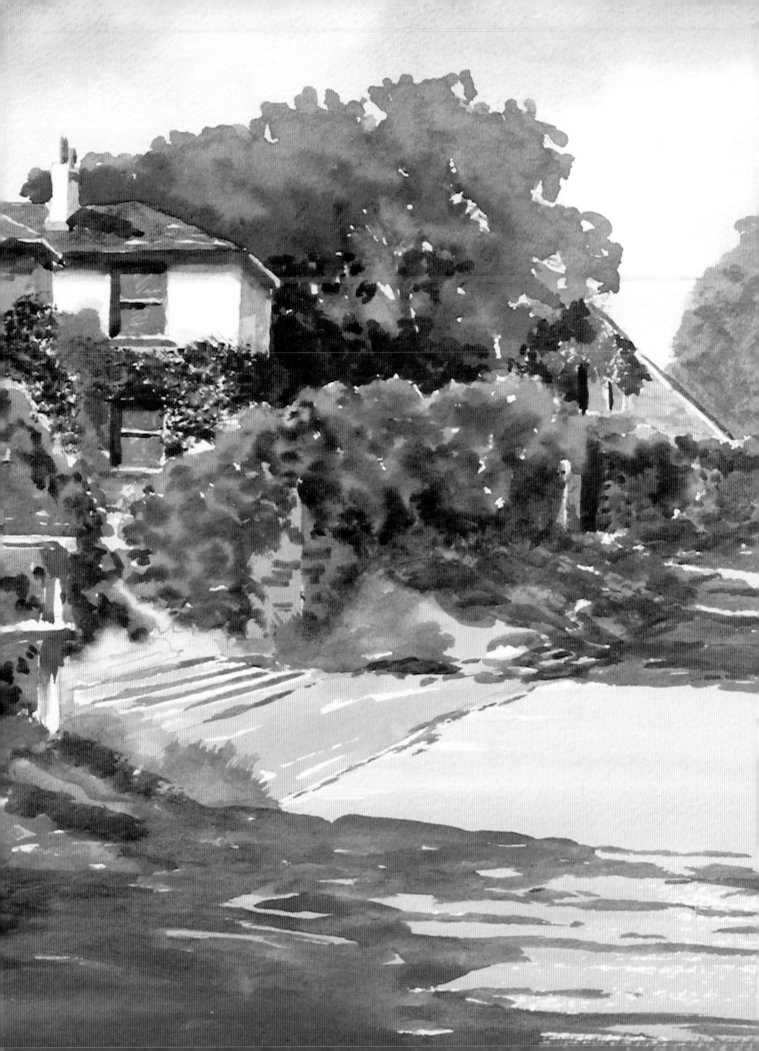

Houses and Lane

Buildings don't have to be the focal point in a picture. Here, a few houses half-hidden down a country lane are all you need.

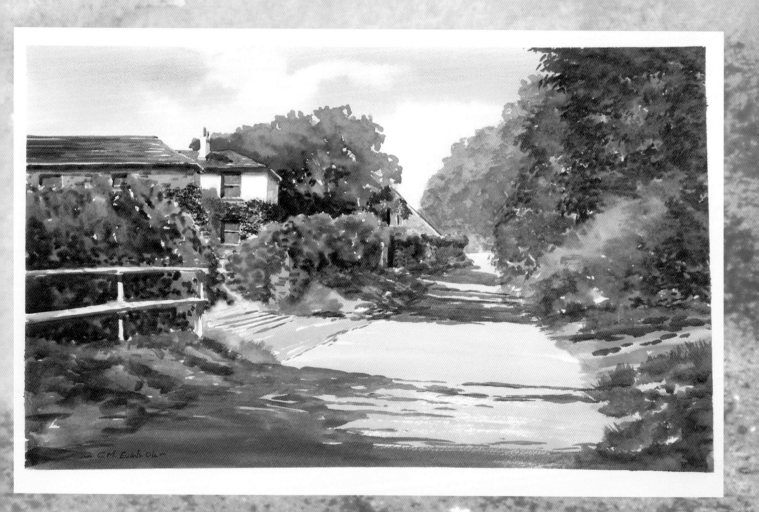

All I have here to start with is a very simple basic outline drawing. I never use crosshatching or shading in preliminary pencil drawings because any texture or detail work should be done in the painting by the paint.

1 With a large wash I wet the sky area, then work from the top down with a watery wash of French ultramarine. I go through the tops of the trees, so that any gaps will be sky colour, not white paper.
2 I rinse and squeeze out the brush, then draw out the pigment for the clouds and let the sky dry, but not completely.

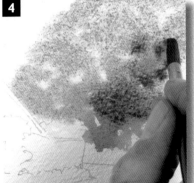

3 Switching to a No. 8 round brush, I drop in Hooker's green and burnt sienna for the trees in the middle distance. The still-damp paper creates soft edges.
4 While this is still wet, I add a watery wash of French ultramarine, mainly along the bottom, which gives a feeling of 'what's around the corner'.

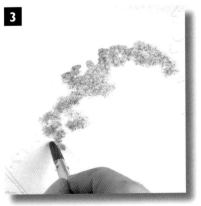

5 With a touch of raw umber I very loosely drop in the basic colour for the furthest building; at this stage I'm just blocking in, with no detail. I add a little texture to the slightly wet paper with a tiny bit of light red, and while this is drying I fill in the windows with a mix of French ultramarine and a very little burnt sienna.

6 On the nearest building I block in the shadow side of the white walls with the same mix as for the windows.

7 Working within the window frames, I use the mix for the glass panes, leaving white highlights.

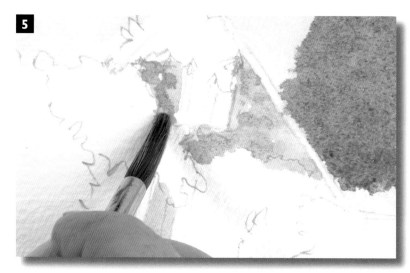

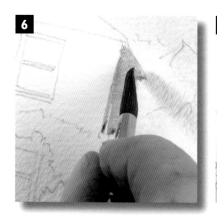

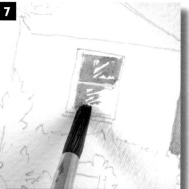

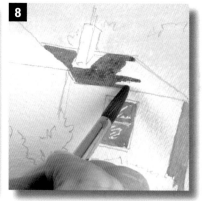

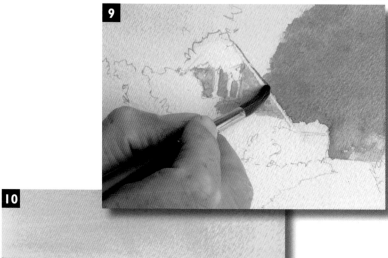

8 For the roof of the white building I use burnt sienna with a tiny touch of raw umber. Again, I don't go into detail and leave a few smidgens of white. I then paint the shadow side the same colour as the side of the building.

9 While this is drying, I move back to the furthest building – which means that I get on with the painting more quickly than if I were to use a hairdryer to dry one part. I use the roof mix from step 8 to add the roof line.

10 For the roof of the barn on the left I use a slightly darker version of the burnt sienna and raw umber mix of the other roofs. As always, I make sure to leave some white – if I need white, there's no finer white than that of the paper.

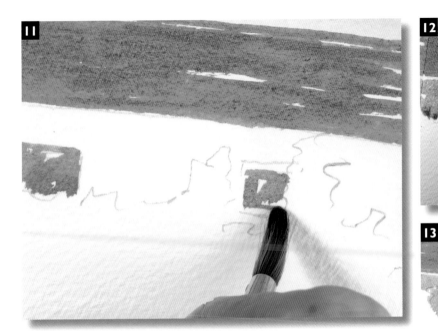

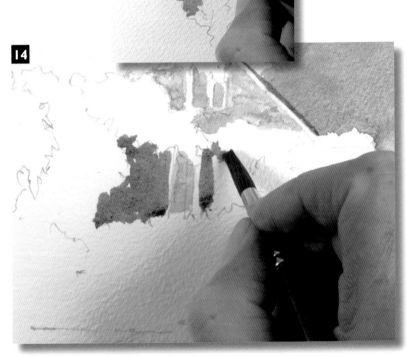

11 For the windows of the barn I use a darker version of the French ultramarine and burnt sienna mix I used on the other buildings.

12 I make up a very watered wash of raw umber for the barn walls, painting this into the tree shapes.

13 Where the main barn wall goes into shadow, I add a touch of French ultramarine to the raw umber to darken it slightly.

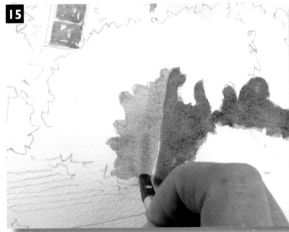

14 While the paint on the barn wall dries, I move back to the furthest building and colour in the shadow side of the garden wall with the raw umber and French ultramarine mix, making sure it gets weaker the further into the distance it goes.

15 I bring this colour all the way along the wall, and then dilute the mix to go round the corner to the front-facing part of the wall in front of the white building.

HOUSES AND LANE

16 Adding some burnt sienna into the wall mix, I put some stones into the barn wall – just a few strokes, as I'm painting the wall, not building it.

17 To get a slightly darker tone, I add a touch of French ultramarine into the mix.

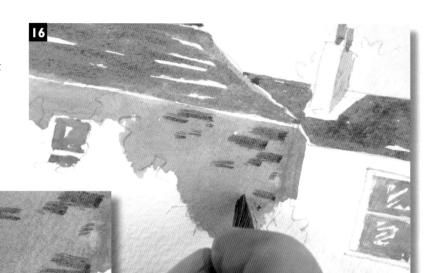

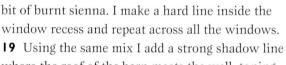

18 For the shadow colour on the buildings I mix French ultramarine and alizarin crimson to get a fairly awful purple, and then tone it down with a bit of burnt sienna. I make a hard line inside the window recess and repeat across all the windows.

19 Using the same mix I add a strong shadow line where the roof of the barn meets the wall, toning this down with a clean damp brush.

20 I then put in a few touches of the shadow mix along the barn roof – for a big, solid roof such as this, I need to make quite wide marks.

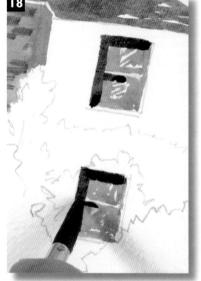

21 After adding quite a bit of water to the shadow mix I apply it lightly to show the shadows of the foliage on the front of the white building.

22 I then add some shadows to fill in the gaps on the furthest building, down the gate and on the chimneys, using the same watery mix.

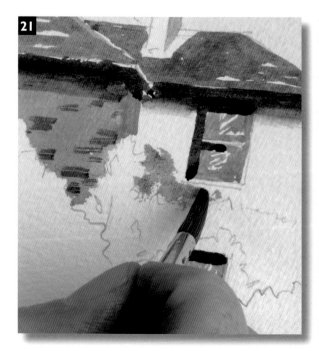

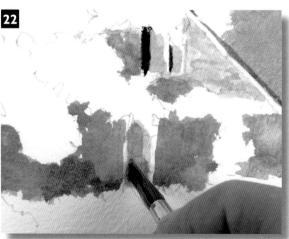

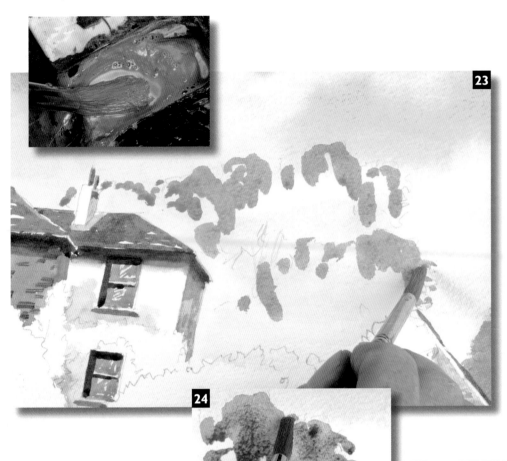

23 Once again while everything is drying, I move on to another part of the painting. For the big trees behind the buildings, I start with a well watered wash of yellow ochre for the top part.

24 I make a light mix of Hooker's green and burnt sienna and go over most of the first wash, remembering to leave a few gaps of the sky colour through the foliage.

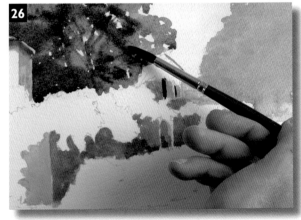

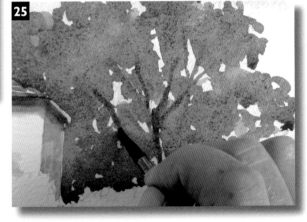

25 Still keeping an eye on the gaps in the trees, I apply a mix of raw umber and French ultramarine to show a few boughs; even though the main trunk is hidden from view, the branches must be believable and not look as if they're hanging in thin air.

26 Where the foliage comes down to meet the buildings I add some French ultramarine to the green mix – this makes the buildings zing out of the background. I merge the colours together with the side of the brush while they are still damp.

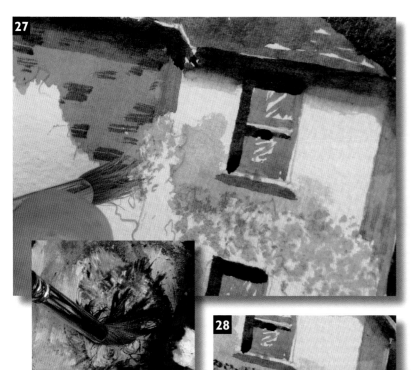

27 For the ivy growing up the buildings I split the hairs of the round brush and dab yellow ochre on to the paper, not atempting to paint each and every leaf.

28 Over this I put a nice strong mix of Hooker's green and burnt sienna, again splitting the hairs and dabbing the colour on.

29 Even ivy is going to cast a shadow, so I go back to the basic shadow mix of French ultramarine, alizarin crimson and burnt sienna and stipple it over the other washes with split hairs.

30 I repeat steps 27, 28 and 29 for the ivy on the furthest building, using the same technique and weaker versions of each of the mixes to give the impression of greater distance. The technical term for this is 'tonal recession'.

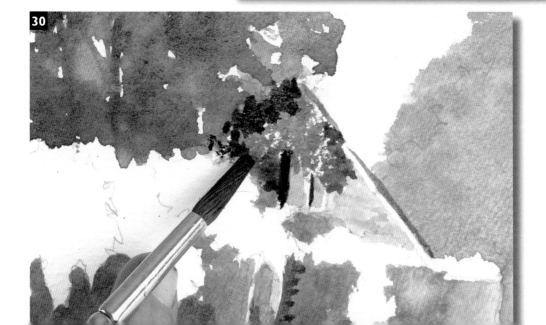

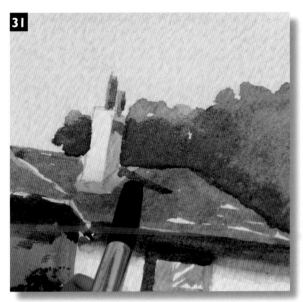

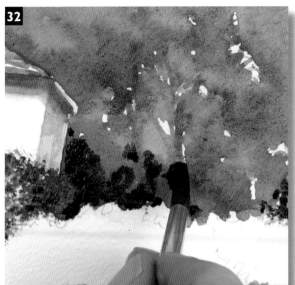

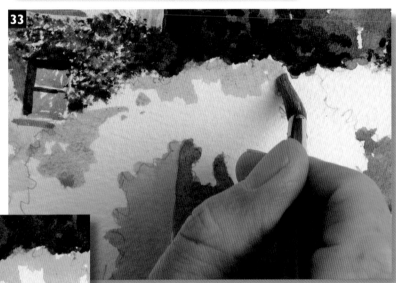

31 With the shadow mix I cast a little shadow from the chimney on to the roof of the white building.

32 I then use a much stronger version to darken the bases of some of the trees.

33 As this dries, I return to yellow ochre to dab a first wash on to the foreground bushes.

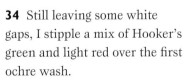

34 Still leaving some white gaps, I stipple a mix of Hooker's green and light red over the first ochre wash.

35 Once again I go in with the shadow colour on the wet washes, keeping this colour darkest in the gateway to the building in the distance.

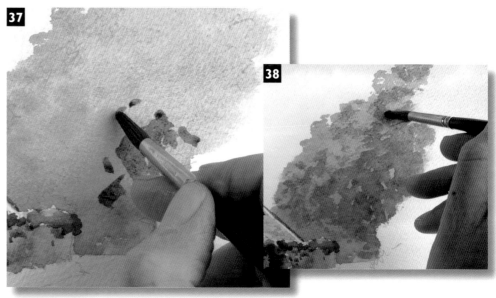

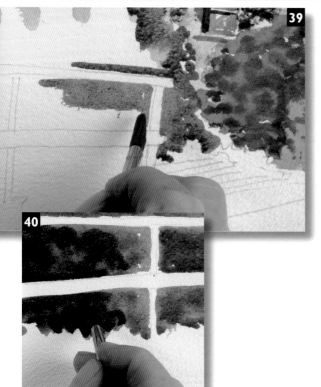

36 I add a few strokes of a raw umber, French ultramarine and burnt sienna mix for the stones in the garden wall, not trying to add detail but a bit of texture.

37 While this is drying, I go back to the trees in the distance and apply a mix of Hooker's green and French ultramarine to bring in some texture and contours.

38 I then strengthen the mix and add a few shadows among the mass of foliage.

39 I use the same mix as in step 37 to block in the bush in front of the barn, still leaving some gaps and cutting in front of the ivy on the buildings. Again I strengthen the mix to add variety and texture.

40 Where the bush is darkest I add some of the shadow mix, being careful to cut in around the white fence as a negative shape, rather than using masking fluid.

41 I fill in the gaps in the near gateway with a little light red on the steps and inner path, and then mix this with raw umber and plenty of water for the main path.

42 Changing to a ¾ in flat wash brush, I use the same watery mix to pick up the surface of the paper for the main track of the lane, keeping the colour lighter further away. I then let everything dry completely.

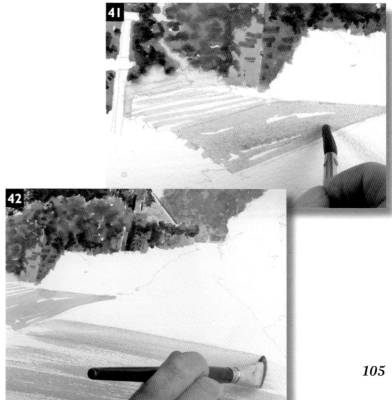

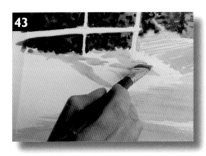

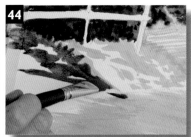

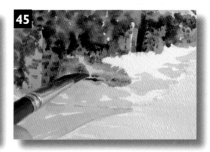

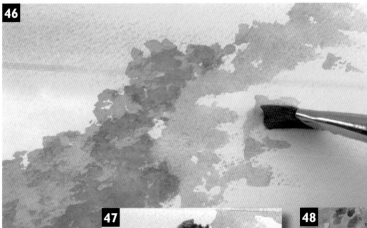

43 To start the grass verges, I apply yellow ochre with the flat wash brush.

44 While this is wet, I dab on a mix of Hooker's green, burnt sienna and a touch of French ultramarine.

45 I tap with the corner of the brush in the furthest bits of the verges, leaving some white.

46 While this is drying, I move to the right-hand trees, using the side of the wash brush to tap on some yellow ochre.

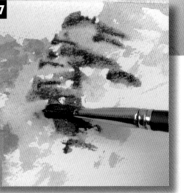

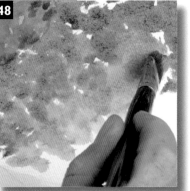

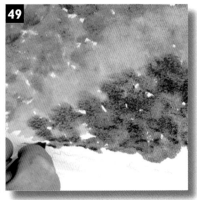

47 I use the side of the brush again to tap on a mix of Hooker's green and burnt sienna – now the distant trees look even further away.

48 At the front of the trees I use yellow ochre with a bit of alizarin crimson.

49 While this is wet I stipple on a mix of Hooker's green, French ultramarine and burnt sienna, splitting the brush hairs and allowing some background to show through. I then add some French ultramarine to darken the trees.

50 I leave the trees and start the right foreground verge with yellow ochre.

Top Tip

IF YOU DON'T LEAVE GAPS IN TREES AND BUSHES, THE BIRDS CAN'T FLY INTO OR THROUGH THEM!

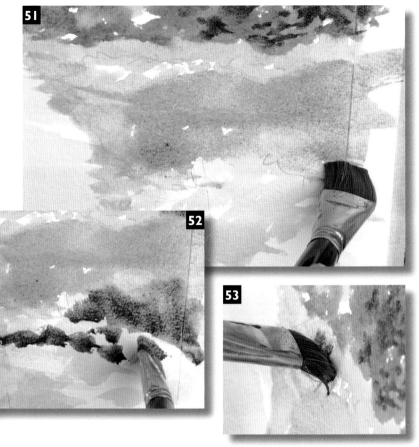

51 I splash a daub of a raw umber and light red mix from the track into the right-hand edge.

52 For a rich, dark green I apply a mix of Hooker's green, burnt sienna and French ultramarine over the wet washes.

53 I flick and dab the green mix to show the rough patches of grass, allowing some of the original ochre wash to show through.

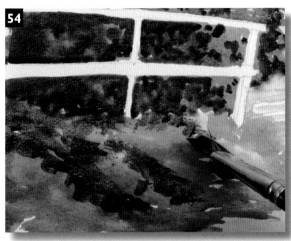

54 While this dries, I return to the left-hand verge with the shadow mix, using the side of the wash brush to bring the shadows down the verges to the lane.

55 I switch to the No. 8 round brush to put the shadow mix along the white fence posts and a very diluted version along the rails. I then add the shadows to the right-hand verge.

56 To tie the painting together, I apply a very diluted dark wash of the shadow mix across the lane from the verge.

57 I block in these shadows, add shadow lines to the steps with a light mix of shadow colours, and allow everything to dry. I then remove the tape for a crisply framed finished painting.

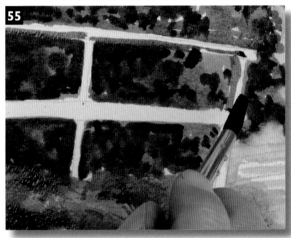

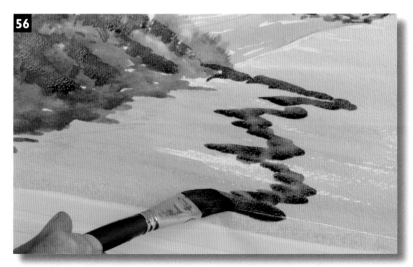

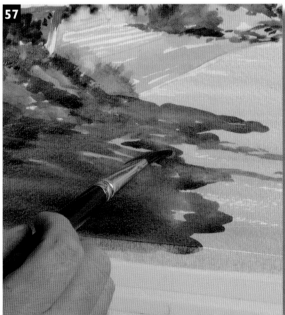

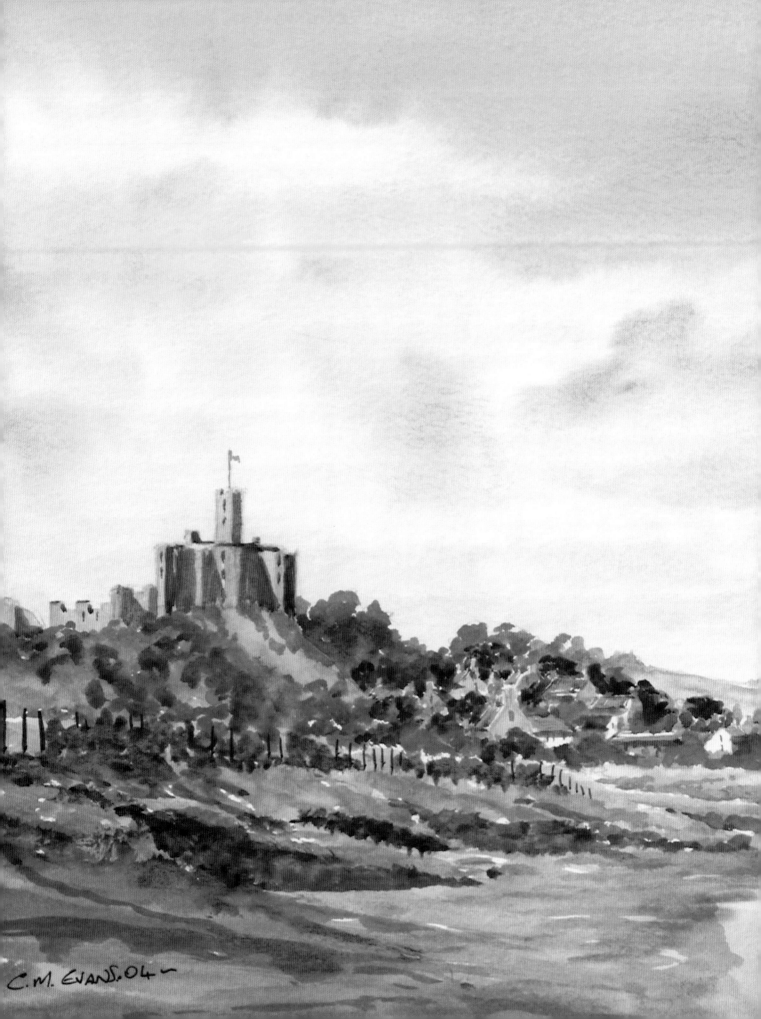

C.M. EVANS. 04

Castle and Estuary

After the quiet country lane in the last project,

I decided to go for something grander: this is

Warkworth Castle in Northumberland.

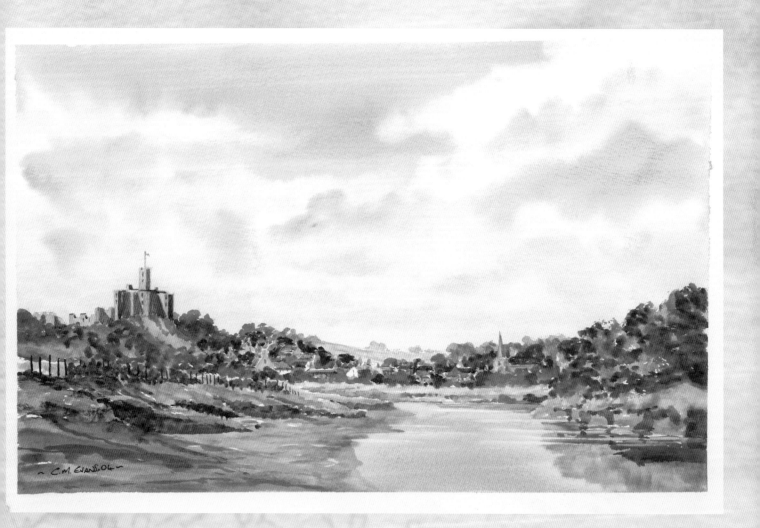

In this view, from the River Coquet, there's quite a lot of detail. I didn't try to draw it all, but focused on getting the castle fairly true to life; after that I just picked out some of the prominent and large buildings, and then stuck in a few rooftops and chimneys for a general impression. Working outdoors, the only race is to get the sky down on paper – after that you can relax, enjoy yourself, look at the view around you and soak up the atmosphere.

1 With a large flat wash brush I wet the entire sky area. I then use the brush to mix together a little yellow ochre and burnt sienna, and put it on to the bottom of the areas and bring it upwards. While this is still wet I add some touches of French ultramarine above it.

2 Still with the sky area wet, I mix French ultramarine and light red for the outer blue areas at each side. As always with skies, I work quickly into the wet paper and washes.

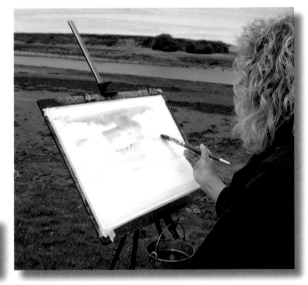

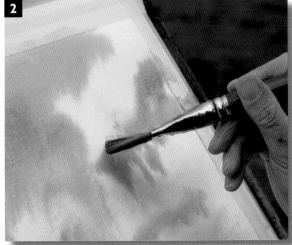

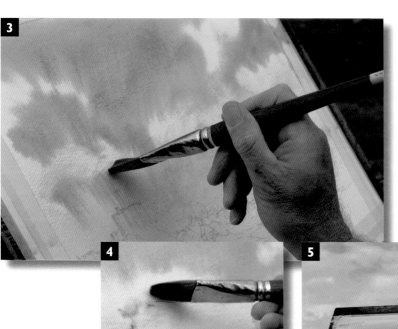

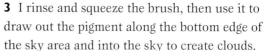

3 I rinse and squeeze the brush, then use it to draw out the pigment along the bottom edge of the sky area and into the sky to create clouds.
4 For the darker patches beneath the clouds, I use the French ultramarine and light red mix. So far, this has taken under five minutes.
5 As the sky dries, the first mix begins to come to the fore and creates a glow among the clouds; this will have an influence on the rest of the picture.

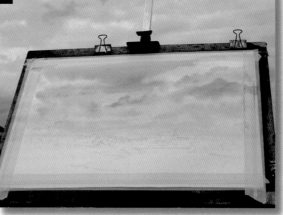

6 Now I move to the landscape in the far distance. Switching to a No. 8 round brush, I make up a weak mix of French ultramarine and light red and drop this in for the trees on the horizon, which look like a few lumpy bits.
7 Below these I put on a little bit of well-watered yellow ochre and stroke the pigment down – I don't make horizontal or vertical strokes for hills, but follow the actual contours.
8 For the trees and bushes here I use a mix of yellow ochre and a tiny hint of Hooker's green.

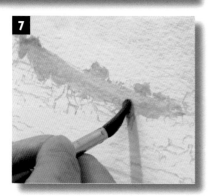

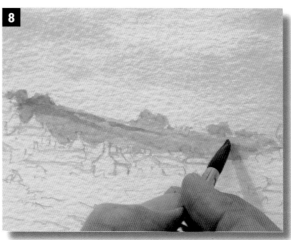

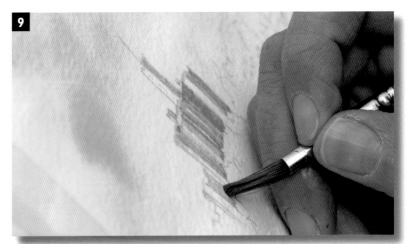

9 To start the castle I make up a mix of raw umber and yellow ochre. The light is coming from the left, so I use this mix for the darker parts on the right – these shadows create the true form.

10 I then put straight yellow ochre on to the sunlit parts while the shadowed sides are still wet.

11 For the church spire and tower in the town I use the raw umber and yellow ochre mix.

12 Next I add a little French ultramarine to the mix for the shadow side of the spire and the church roof.

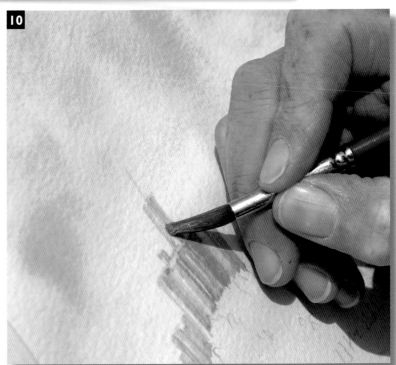

CASTLE AND ESTUARY

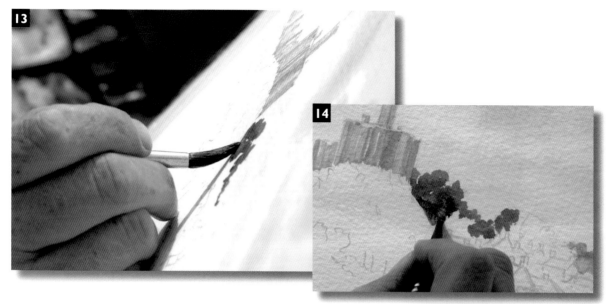

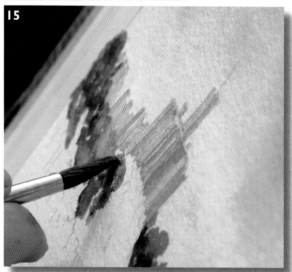

13 With a darkish but watery mix of Hooker's green and French ultramarine I drop in some of the distant trees by the castle.

14 While this wash is still wet, I add a mix of Hooker's green and burnt sienna and merge this in from below.

15 I then bring the mixes in from the right across the front of the castle, cutting into the building carefully. Here and there I add a few touches of yellow ochre to merge with the darker colours.

16 To soften the base of the general mêlée of trees here, I use a fairly weak wash of French ultramarine.

17 I apply a light wash of Hooker's green and yellow ochre for the hillside on which the castle is standing.

18 For the darker greens going into the houses and filling in the tree areas across the church and over to the right, I use a mix of Hooker's green and burnt sienna.

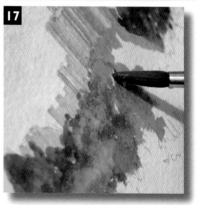

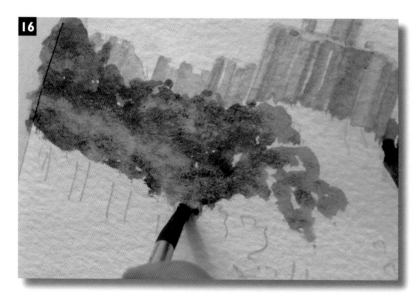

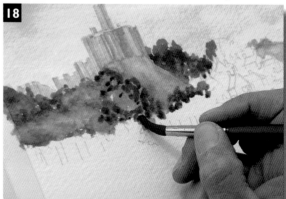

19 While the tree washes are drying I make up my shadow colour mix of French ultramarine, alizarin crimson and burnt sienna – you should know this recipe by heart now! – and put the very darkest shadow areas on the castle.

20 I have a look at which parts will cast shadows on to adjacent areas of the castle, especially the castellation to the left of the main building. I put in very light verticals for windows.

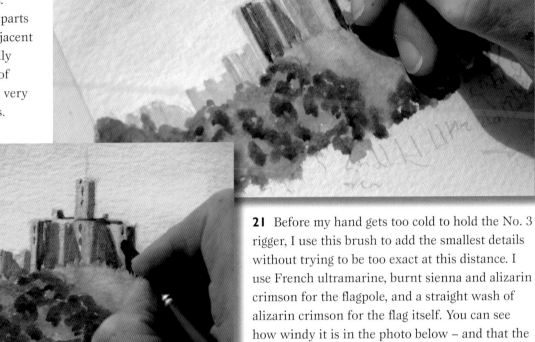

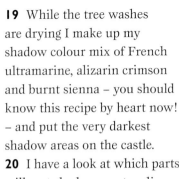

21 Before my hand gets too cold to hold the No. 3 rigger, I use this brush to add the smallest details without trying to be too exact at this distance. I use French ultramarine, burnt sienna and alizarin crimson for the flagpole, and a straight wash of alizarin crimson for the flag itself. You can see how windy it is in the photo below – and that the clouds have now covered the sky, which is why you need to get skies down quickly.

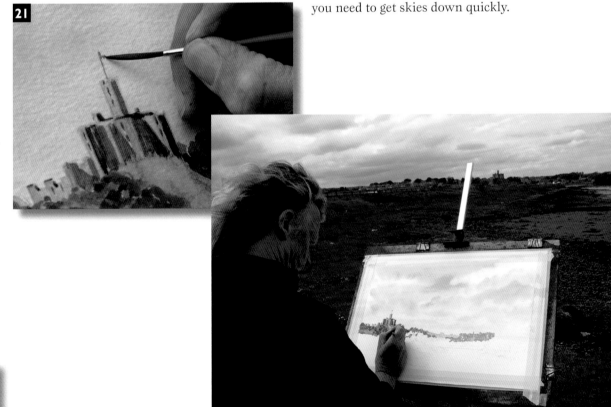

CASTLE AND ESTUARY

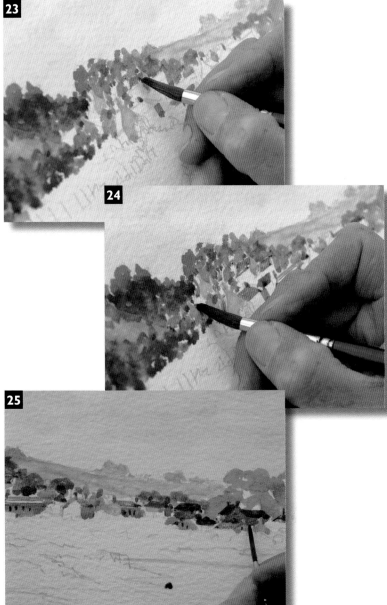

22 Switching back to the round brush, I use a light wash of raw umber to block in some of the buildings among the foliage.

23 I use a darker wash of raw umber for the shadow side of some of the buildings; this brightens up the light side.

24 For most of the rooftops across the whole picture I use a wash of burnt sienna, and then make a contrasting mix of French ultramarine and burnt sienna for the remaining roofs. I use this mix to fill in the shadows among the trees by the church.

25 Moving to the nearest buildings, I use a very watery wash of raw umber for the brighter side, and French ultramarine and burnt sienna for the sides that are in shadow.

26 With the rigger brush, I use my shadow colour to put in just the impression of a few windows in the houses, then switch back to the round brush for some bits of roof shadow.

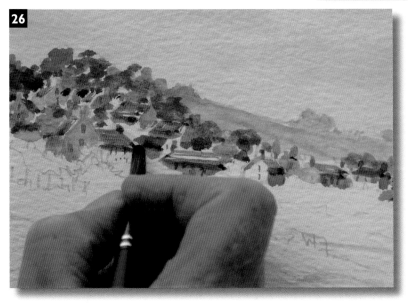

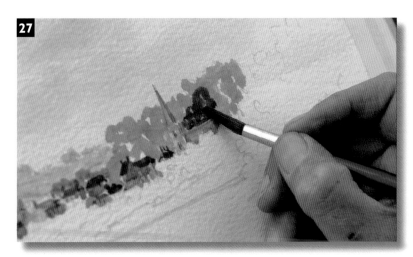

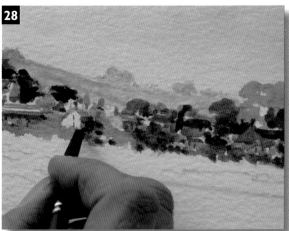

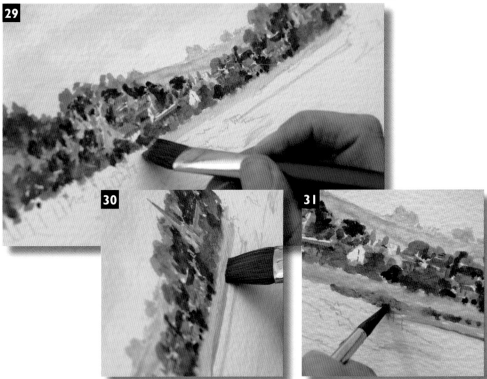

27 To put the darker trees over the lighter dry washes around the church and above the town I use a mix of Hooker's green, burnt sienna and French ultramarine.

28 I then put a diluted version of this mix along the bottom of the buildings.

29 For the light strand below the buildings I apply a wash of yellow ochre with a ¾in flat wash brush.

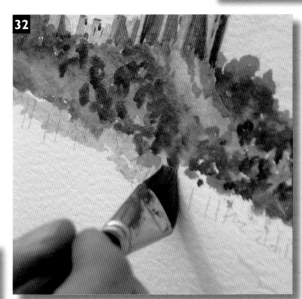

30 Using the same brush I then go below this line with a light mix of Hooker's green and burnt sienna to make an even thinner line...

31 ...and below this I switch back to the round brush to apply the green mix with some French ultramarine in it.

32 Going back to the area below the castle, I start by cutting into the green with the flat brush and a wash of yellow ochre.

33 With the ¾in flat wash brush I bring down the yellow ochre while it is still wet.

34 I then go into this with a mix of Hooker's green and burnt sienna, leaving some patches of white paper.

35 Back with the flat brush I continue to bring the green down, just making a few marks and not attempting to block in the colour.

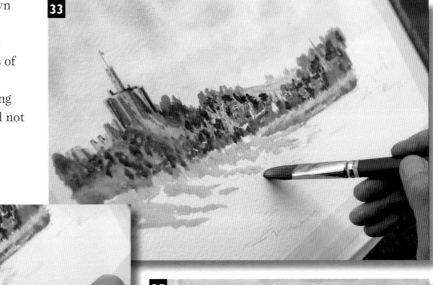

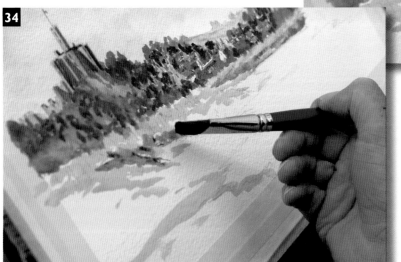

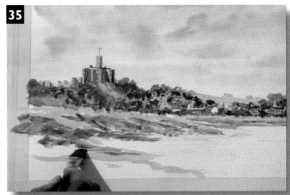

36 Even when I bring down the green to the foreground, I take care not to make the shade a solid one.

37 I switch back to the round brush and a stronger version of the green mix for the bushes.

38 For the smallest marks here I use the side of the brush as well as the tip.

39 Using the shadow mix of French ultramarine, alizarin crimson and burnt sienna, I add more darks among the bushes and create contours and shadow areas among the grasses, going down to the river bank.

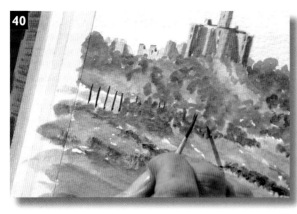

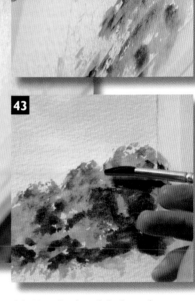

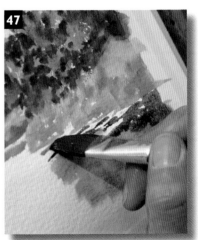

40 With an almost black mix of French ultramarine and burnt sienna and using the rigger brush, I add the fence posts, getting smaller in the distance.

41 I start the trees on the right with the flat brush, tapping yellow ochre on to the paper.

42 While this is wet, I tap on a mix of Hooker's green and burnt sienna to give a ragged edge.

43 Back with the round brush I drop in a watery mix of French ultramarine and burnt sienna so that it merges with the first two washes.

44 For the bank below the trees I use the flat brush to put in yellow ochre and then a mix of Hooker's green and burnt sienna below that.

45 I then add a mix of raw umber and French ultramarine for the muddy shore, merging this into the bank washes.

46 After wetting all the river area, I put in a wash of Hooker's green and burnt sienna for the reflections of the trees.

47 I then put in quite a strong mix of French ultramarine and burnt sienna for the ripples on the right by the bank.

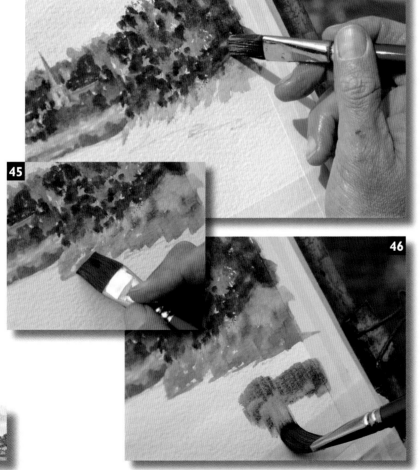

CASTLE AND ESTUARY

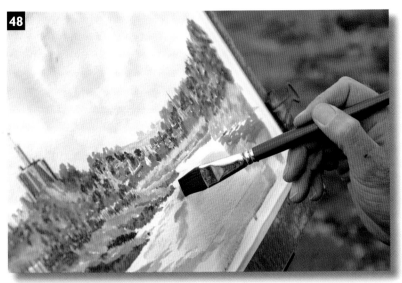

48 Just as with the sky, I aim to have the river area finished within no more than three or four minutes. I start by brushing on a watery mix of French ultramarine and a tiny bit of light red, merging this in softly with the other washes in the river.

49 I rinse and squeeze out the flat brush and draw out the paint in horizontal bands to show the highlights in the water and create some movement. It's important not to overdo this – if each strip cost £5 to take out, how many would you remove?

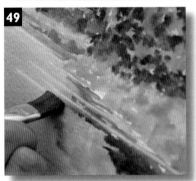

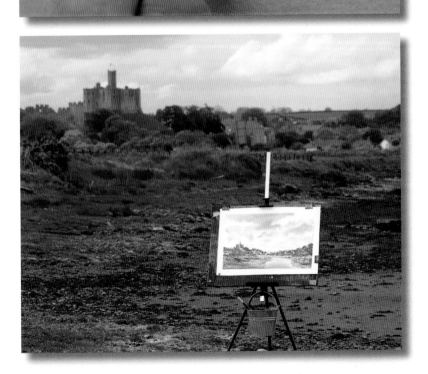

50 Using my shadow mix and the round brush, I add a little shadow beneath the right-hand bank, and then do the same for the left-hand bank in the foreground.

51 Finally I go back to the flat wash brush and use a mix of raw umber and yellow ochre to give the impression of a muddy stretch going down to the water on the left. I stroke on the watery wash horizontally, taking care not to dull the highlights.

Et voilà! My big outdoor adventure is finished, and even if the sky has cleared up, it's time to pack up quickly and find a nice warm café to have a cup of tea and thaw out my fingers.

Index

Entries in **bold** refer to projects

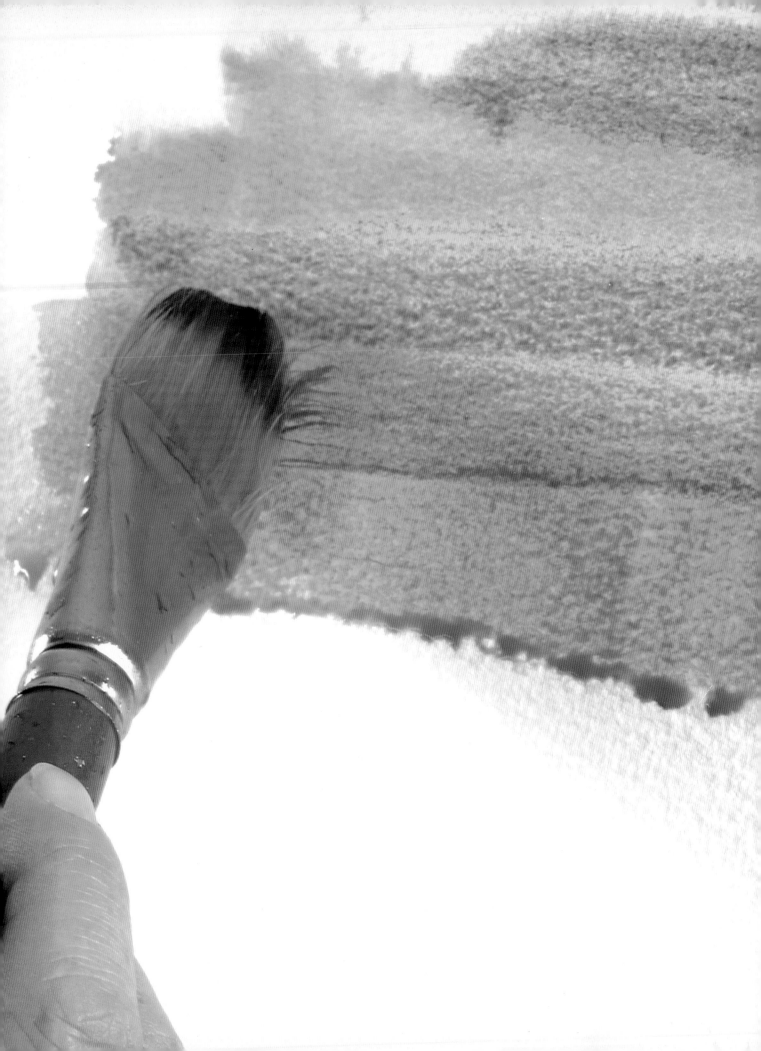